Sergio Larrain

VALPARAISO.

1

Alham du li lah!

3

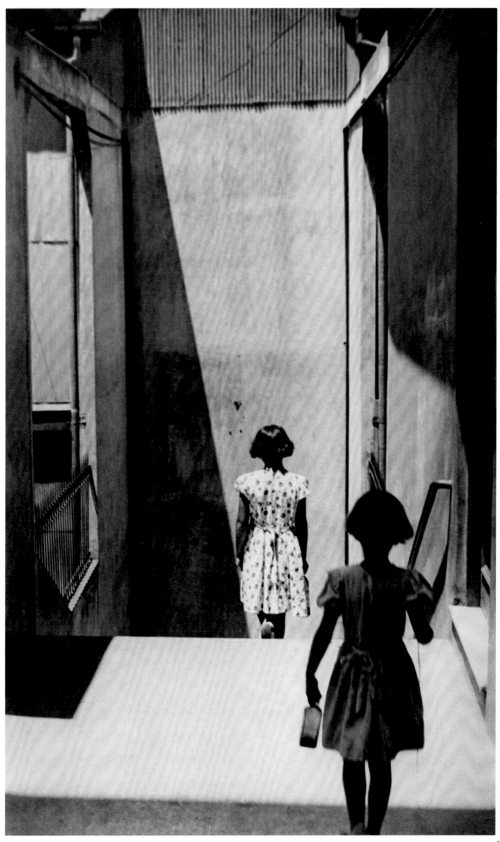

4

5

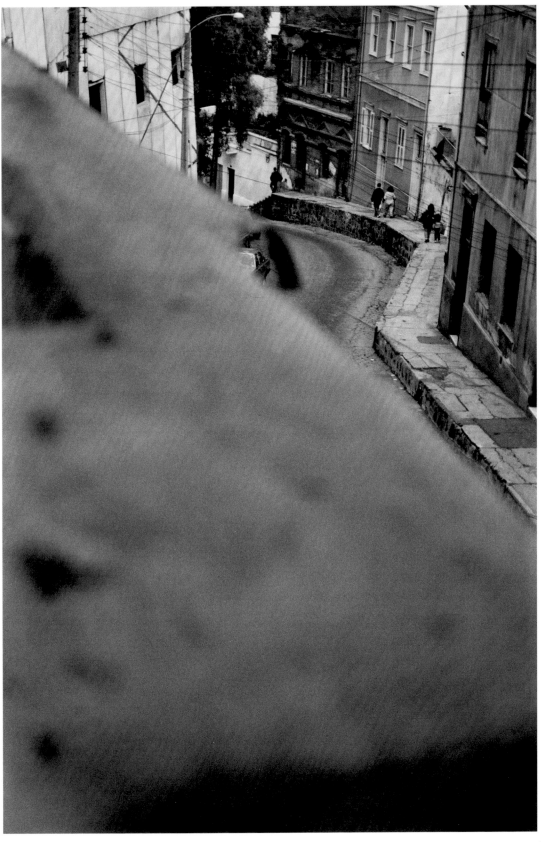

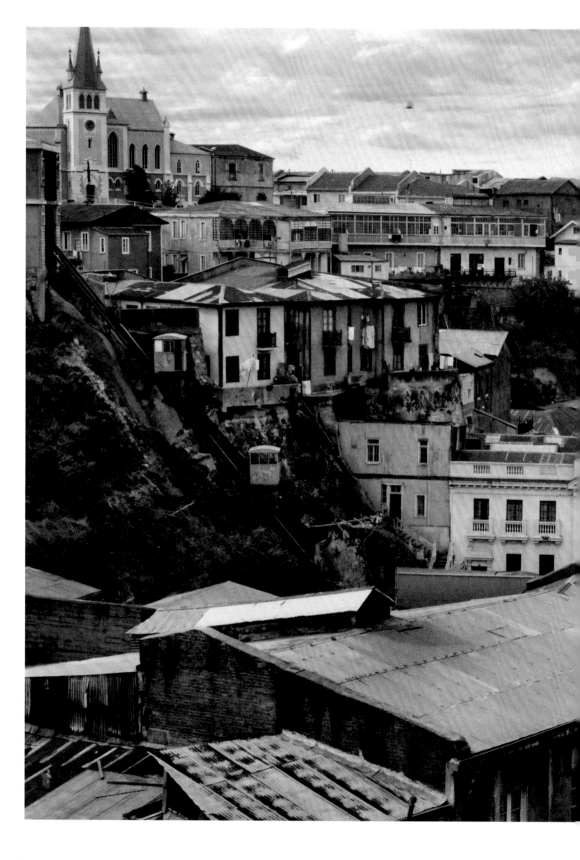

7

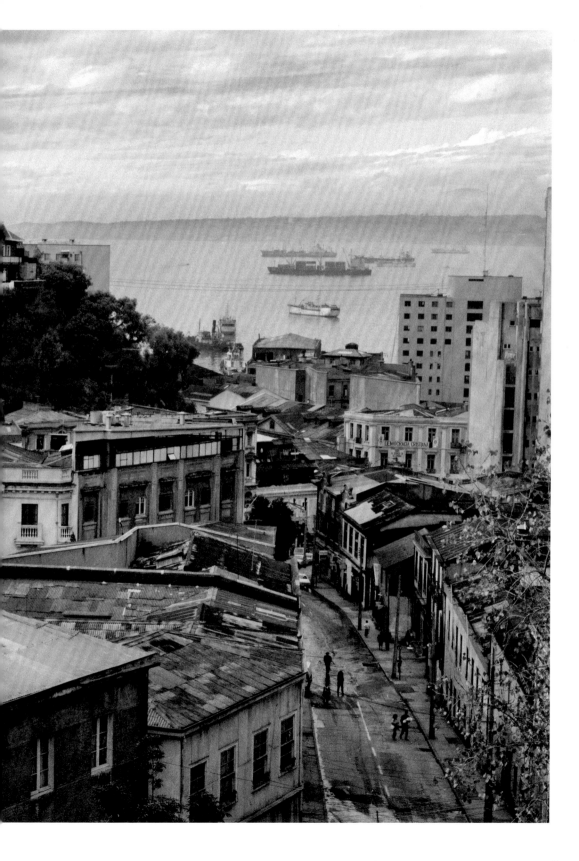

The Vagabond of Valparaíso

Pablo Neruda

For several weeks I lived across from Don Zoilo Escobar's house on a narrow street in Valparaíso. Our balconies almost touched. My neighbour would come out on his balcony early in the morning to do exercises like a hermit, exposing the harp of his ribs. Invariably dressed in a poor man's overalls or a frayed overcoat, half sailor, half archangel, he had retired long ago from his sea voyages, from the customs house, from the ships' crews. He brushed his Sunday suit every day with the meticulous thoroughness of a perfectionist. It was a distinguished-looking black flannel suit that, over the years, I never saw him wear – an outfit he kept among his treasures in a decrepit old wardrobe.

But his most precious and heart-rending treasure was a Stradivarius which he watched over with devotion all his life, never playing it or allowing anyone else to. Don Zoilo was thinking of selling it in New York, where he would be given a fortune for the famed instrument. Sometimes he brought it out of the dilapidated wardrobe and let us look at it, reverently. Someday Don Zoilo would go north and return without a violin but loaded with flashy rings and with gold teeth filling the gaps the slow passing of the years had gradually left in his mouth.

One morning he did not come out to his gymnasium balcony. We buried him in the cemetery up on the hill, in his black flannel suit, which covered his small hermit's bones for the first time. The strings of the Stradivarius could not weep over his departure. Nobody knew how to play it. Moreover, the violin was not in the wardrobe when it was opened. Perhaps it had flown out to sea, or to New York, to crown Don Zoilo's dreams.

Valparaíso is secretive, sinuous, winding. Poverty spills over its hills like a waterfall. Everyone knows how much the infinite number of people on the hills eat and how they dress (and also how much they do not eat and how they do not dress). The wash hanging out to dry decks each house with flags and the swarm of bare feet constantly multiplying betrays unquenchable love.

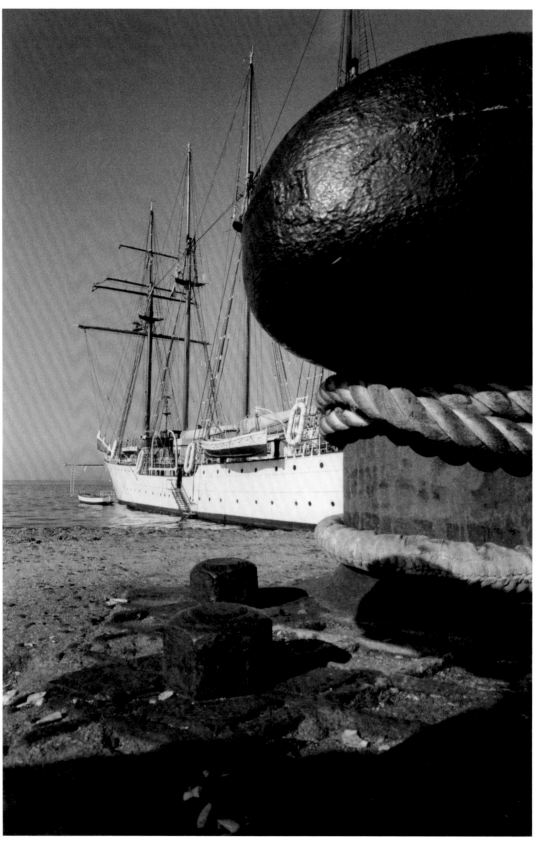

11

Near the sea, however, on flat ground, there are balconied houses with closed windows, where hardly any footsteps ever enter. The explorer's mansion was one of those houses. I knocked repeatedly with the bronze knocker to make sure I would be heard. At last, soft footfalls approached and a quizzical face suspiciously opened the portal just a crack, wanting to keep me out. It was the old serving woman of the house, a shadow in a square shawl and an apron, whose footsteps were barely a whisper.

The explorer, who was also quite old, and the servant lived all alone in the spacious house with its windows closed. I had come there to see what his collection of idols was like. Corridors and walls were filled with bright-red creatures, masks with white and ash-coloured stripes, statues representing the vanished anatomies of sea gods, wigs of dried-up Polynesian hair, hostile wooden shields covered with leopard skin, necklaces of fierce-looking teeth, the oars of skiffs that may have cut through the foam of favourable waters. Menacing knives made the walls shudder with silver blades that gleamed through the shadows.

I noticed that the virile wooden gods had been emasculated. Their phalluses had been carefully covered with loincloths, obviously the same cloth used by the servant for her shawl and her apron.

The old explorer moved among his trophies stealthily. In room after room, he supplied me with the explanations, half peremptory and half ironic, of someone who had lived a good deal and continued to live in the afterglow of his images. His white goatee resembled a Samoan idol's. He showed me the muskets and huge pistols he had used to hunt the enemy and make antelopes and tigers bite the dust. He told his adventures without varying his hushed tone. It was as if the sunlight had come in through the closed windows to leave just a tiny ray, a tiny butterfly, alive, flitting among the idols.

On my way out, I mentioned a trip I planned to the Islands, my eagerness to leave very soon for the golden sands. Then, peering all around him, he put his frazzled moustache to my ear and shakily let slip: 'Don't let her find out, she mustn't know about it, but I am getting ready for a trip, too.'

He stood that way for an instant, one finger on his lips, listening for the possible tread of a tiger in the jungle. And then the door closed on him, dark and abrupt, like night falling over Africa.

I questioned the neighbours: 'Are there any new eccentrics around? Is there anything worth coming back to Valparaíso for?'

They answered: 'There's almost nothing to speak of. But if you go down that street you'll run into Don Bartolomé.'

'And how am I going to know him?' 'There's no way you can make a mistake. He always travels in a grand coach.'

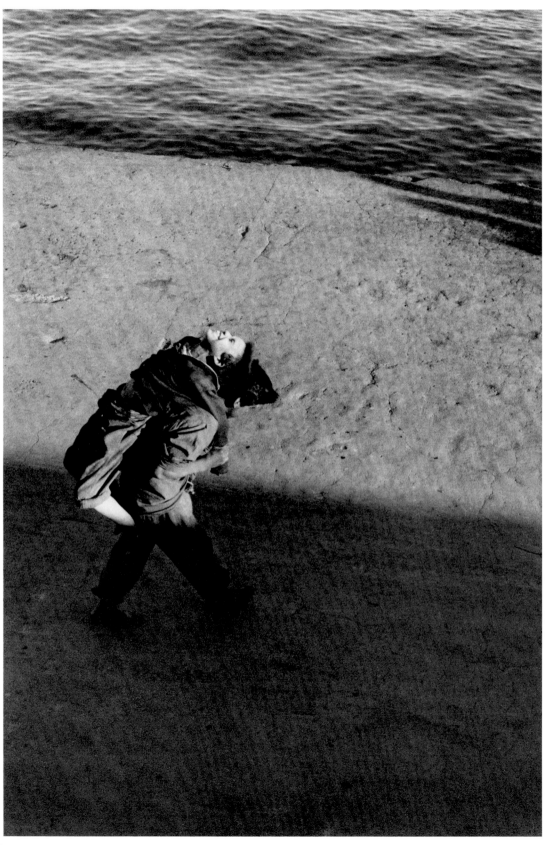

13

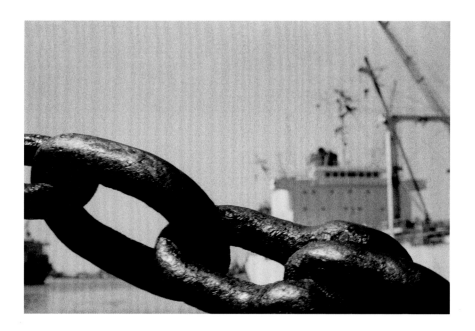

A few hours later I was buying some apples in a fruit store when a horse-drawn carriage halted at the door. A tall, ungainly character dressed in black got out of it. He, too, was going to buy apples. On his shoulder he carried an all-green parrot, which immediately flew over to me and perched on my head without even looking where it was going.

'Are you Don Bartolomé?' I asked the gentleman.

'That's right. My name is Bartolomé.' And pulling out a long sword he carried under his cape, he handed it to me, while he filled his basket with the apples and grapes he was buying. It was an ancient sword, long and sharp, with a hilt worked by fancy silversmiths, a hilt like a blown rose.

I didn't know him, and I never saw him again. But I accompanied him into the street with due respect, silently opened the carriage door for him and his basket of fruit to get in, and solemnly placed the bird and the sword in his hands.

Small worlds of Valparaíso, unjustly neglected, left behind by time, like crates abandoned in the back of a warehouse, nobody knows when, never claimed, come from nobody knows where, crates that will never go anywhere. Perhaps in these secret realms, in these souls of Valparaíso, was stored forever the lost power of a wave, the storm, the salt, the sea that flickers and hums. The menacing sea locked inside each person: an

uncommunicable sound, an isolated movement that turned into the flour and the foam of dreams.

I was amazed that those eccentric lives I discovered were such an inseparable part of the heartbreaking life of the port. Above, on the hills, poverty flourishes in wild spurts of tar and joy. The derricks, the piers, the works of man cover the waist of the coast with a mask painted on by happiness that comes and goes. But others never made it to the hilltops, or down below, to the jobs. They put away their own infinite world, their fragment of the sea, each in his own box. And they watched over it with whatever they had, while oblivion closed in on them like a mist.

Sometimes Valparaíso twitches like a wounded whale. It flounders in the air, is in agony, dies, and comes back to life.

Every native of the city carries in him the memory of an earthquake. He is a petal of fear clinging all his life to the city's heart. Every native is a hero even before he is born. Because in the memory of the port itself there is defeat, the shudder of the earth as it quakes and the rumble that surfaces from deep down as if a city under the sea, under the land, were tolling the bells in its buried towers to tell man that it's all over.

Sometimes when the walls and the roofs have come crashing down in dust and flames, down into the screams and the silence, when everything seems to have been silenced by death once and for all, there rises out of the sea, like the final apparition, the mountainous wave, the immense green arm that surges, tall and menacing, like a tower of vengeance, to sweep away whatever life remains within its reach.

Sometimes it all begins with a vague stirring, and those who are sleeping wake up. Sleeping fitfully, the soul reaches down to profound roots, to their very depth under the earth. It has always wanted to know it. And knows it now. And then, during the great tremor, there is nowhere to run, because the gods have gone away, the vainglorious churches have been ground up into heaps of rubble.

This is not the terror felt by someone running from a furious bull, a threatening knife, or water that swallows everything. This is a cosmic terror, an instant danger, the universe caving in and crumbling away. And, meanwhile, the earth lets out a muffled sound of thunder, in a voice no one knew it had.

The dust raised by the houses as they came crashing down settles little by little. And we are left alone with our dead, with all the dead, not knowing how we happen to be still alive.

The stairs start out from the bottom and from the top, winding as they climb. They taper off like strands of hair, give you a slight respite, and then go straight up. They become dizzy. Plunge down. Drag out.

Turn back. They never end.

How many stairs? How many steps to the stairs? How many feet on the steps? How many centuries of footsteps, of going down and back up with a book, tomatoes, fish, bottles, bread? How many thousands of hours have worn away the steps, making them into little drains where the rain runs down, playing and crying?

Stairways!

No other city has spilled them, shed them like petals into its history, down its own face, fanned them into the air and put them together again, as Valparaíso has. No city has had on its face these furrows where lives come and go, as if they were always going up to heaven or down into the earth.

Stairs that have given birth, in the middle of their climb, to a thistle with purple flowers! Stairs the sailor, back from Asia, went up only to find a new smile or a terrifying absence in his house! Stairs down which a staggering drunk dived like a black meteor! Stairs the sun climbs to go make love to the hills!

If we walk up and down all of Valparaíso's stairs, we will have made a trip around the world.

Valparaíso of my sorrows...! What happened in the solitudes of the South Pacific? Wandering star or battle of glowworms whose phosphorescence survived the disaster?

Night is Valparaíso! A speck on the planet lit up, ever so tiny in the empty universe. Fireflies flickered and a golden horseshoe started burning in the mountains.

What happened then is that the immense deserted night set up its formation of colossal figures that seeded light far and wide. Aldebaran trembled, throbbing far above, Cassiopeia hung her dress on heaven's doors, while the noiseless chariot of the Southern Cross rolled over the night sperm of the Milky Way. Then the rearing, hairy Sagittarius dropped something, a diamond from his hidden hoofs, a flea from his hide, very far above.

Valparaíso was born, bright with lights, and humming, edged with foam and meretricious.

Night in its narrow streets filled up with black water nymphs. Doors lurked in the darkness, hands pulled you in, the bedsheets in the south led the sailor astray. Polyanta, Tritetonga, Carmela, Flor de Dios, Multicula, Berenice, Baby Sweet packed the beer taverns, they cared for those who had survived the shipwreck of delirium, relieved one another and were replaced, they danced listlessly, with the melancholy of my rain-haunted people.

The sturdiest whaling vessels left port to subdue leviathan. Other ships sailed for the Californias and their gold. The last of them crossed the Seven Seas later to pick up from the Chilean desert cargoes of the nitrate that

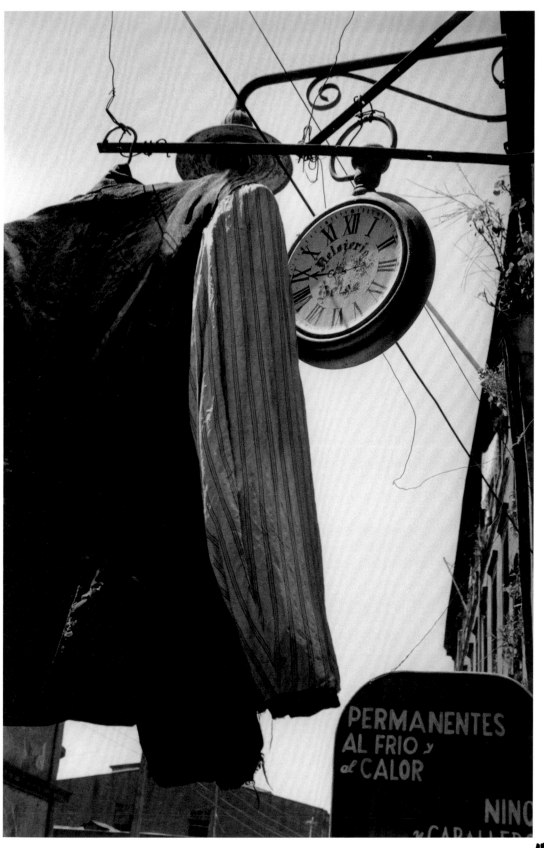

PERMANENTES
AL FRIO y
el CALOR

NIÑO
CABALLERO

18

lies like the limitless dust of a statue crushed under the driest stretches of land in the world.

These were the great adventures.

Valparaíso shimmered across the night of the world. In from the world and out into the world, ships surged, dressed up like fantastic pigeons, sweet-smelling vessels, starved frigates held up overlong by Cape Horn… In many instances, men who had just hit port threw themselves down on the grass… Fierce and fantastic days when the oceans opened into each other only at the far-off Patagonian strait. Times when Valparaíso paid good money to the crews that spit on her and loved her.

A grand piano arrived on some ship; on another, Flora Tristan, Gauguin's Peruvian grandmother, passed through; and on yet another, on the *Wager*, the original Robinson Crusoe came in, in the flesh, recently picked up at the Juan Fernández Islands… Other ships brought pineapples, coffee, black pepper from Sumatra, bananas from Guayaquil, jasmine tea from Assam, anise from Spain… The remote bay, the Centaur's rusty horseshoe, filled with intermittent gusts of fragrance: in one street you were overwhelmed by a sweetness of cinnamon; in another, the smell of custard apples shot right through your being like a white arrow; the detritus of seaweed from all over the Chilean sea came out to challenge you.

Valparaíso then would light up and turn a deep gold; it was gradually transformed into an orange tree by the sea, it had leaves, it had coolness and shade, it was resplendent with fruit.

The hills of Valparaíso decided to dislodge their inhabitants, to let go of the houses on top, to let them dangle from cliffs that are red with clay, yellow with gold thimble flowers, and a fleeting green with wild vegetation. But houses and people clung to the heights, writhing, digging in, worrying, their hearts set on staying up there, hanging on, tooth and nail, to each cliff. The port is a tug-of-war between the sea and nature, untamed on the cordilleras. But it was man who won the battle little by little. The hills and the sea's abundance gave the city a pattern, making it uniform, not like a barracks, but with the variety of spring, its clashing colours, its resonant bustle. The houses became colours: a blend of amaranth and yellow, crimson and cobalt, green and purple. And Valparaíso carried out its mission as a true port, a great sailing vessel that has run aground but is still alive, a fleet of ships with their flags to the wind. The wind of the Pacific Ocean deserved a city covered with flags.

I have lived among these fragrant, wounded hills. They are abundant hills, where life touches one's heart with numberless shanties, with unfathomable snaking spirals and the twisting loops of a trumpet. Waiting for you at one of these turns are an orange-coloured merry-go-round, a friar

walking down, a barefoot girl with her face buried in a watermelon, an eddy of sailors and women, a store in a very rusty tin shack, a tiny circus with a tent just large enough for the animal tamer's moustaches, a ladder rising to the clouds, an elevator going up with a full load of onions, seven donkeys carrying water up, a fire truck on the way back from a fire, a store window and in it a collection of bottles containing life or death.

But these hills have profound names. Travelling through these names is a voyage that never ends, because the voyage through Valparaíso ends neither on earth nor in the word. Merry Hill, Butterfly Hill, Polanco's Hill, Hospital, Little Table, Corner, Sea Lion, Hauling Tackle, Potters', Chaparro's, Fern, Litre, Windmill, Almond Grove, Pequenes, Chercanes, Acevedo's Straw, Prison, Vixens', Doña Elvira's, St Stephen's, Astorga, Emerald, Almond Tree, Rodríguez's, Artillery, Milkmen's, Immaculate Conception, Cemetery, Thistle, Leafy Tree, English Hospital, Palm Tree, Queen Victoria's, Caravallo's, St John of God, Pocuro's, Cove, Goat, Biscayne, Don Elias's, Cape, Sugar Cane, Lookout, Parrasia, Quince, Ox, Flower.

I can't go to so many places. Valparaíso needs a new sea monster, an eight-legged one that will manage to cover all of it. I make the most of its immensity, but I can't take in all of its multicoloured right flank, the green vegetation on its left, its cliff or its abyss.

I can only follow it through its bells, its undulations, and its names. Above all, through its names, because they are taproots and rootlets, they are air and oil, they are history and opera: red blood runs in their syllables.

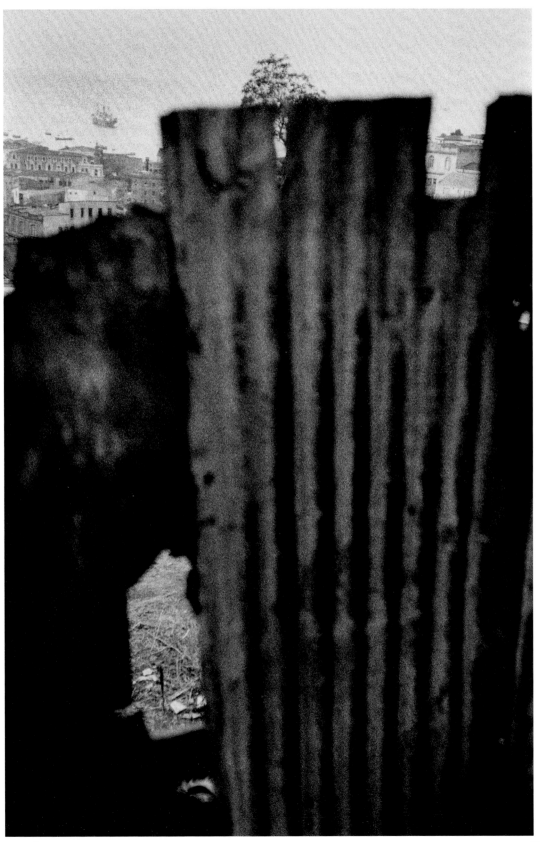

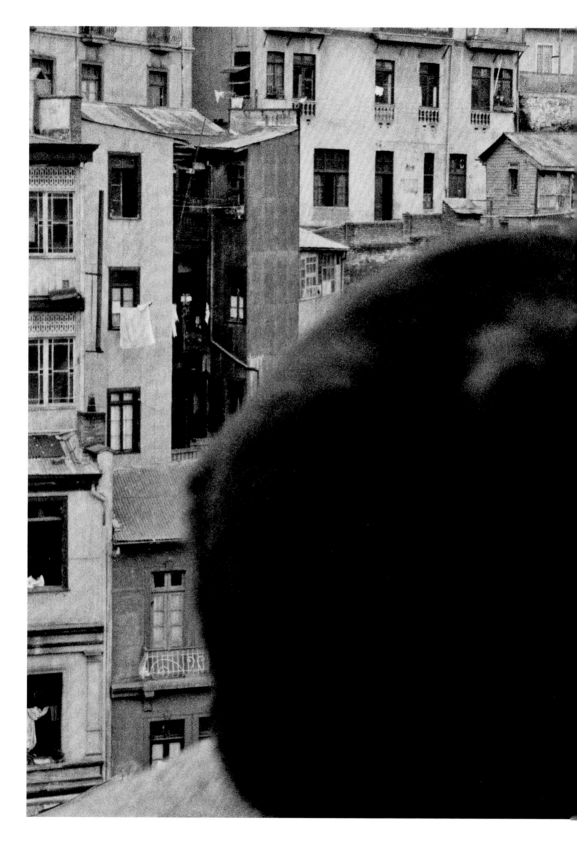

23

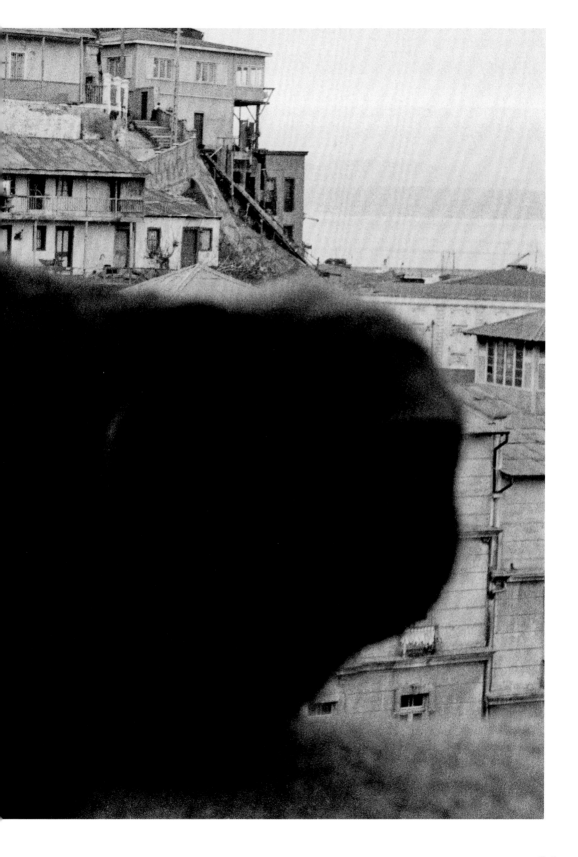

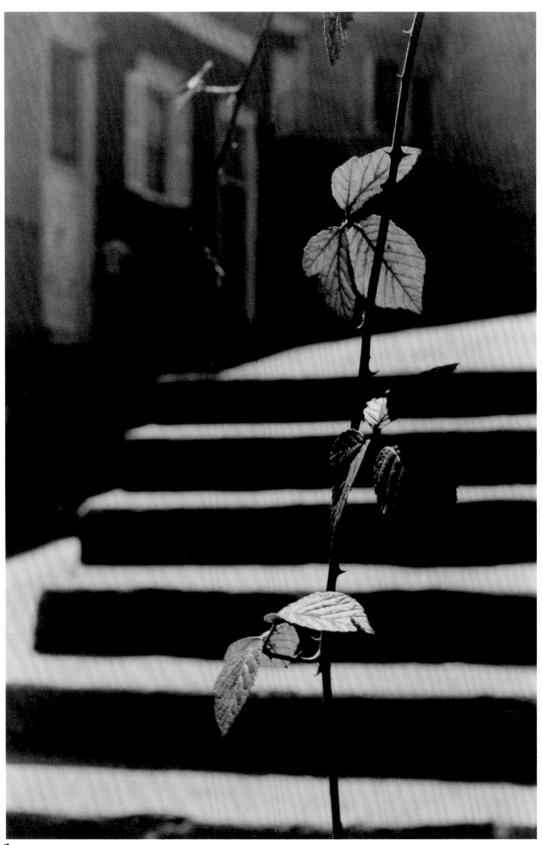

OPENING THE MOMENT
WITH THE RECTANGLE.

• Wandering ar-
round.

(KATH GROUNDED).

In your hands,
the magic box.
You walk in
peace; aware,
in the garden
of forms.

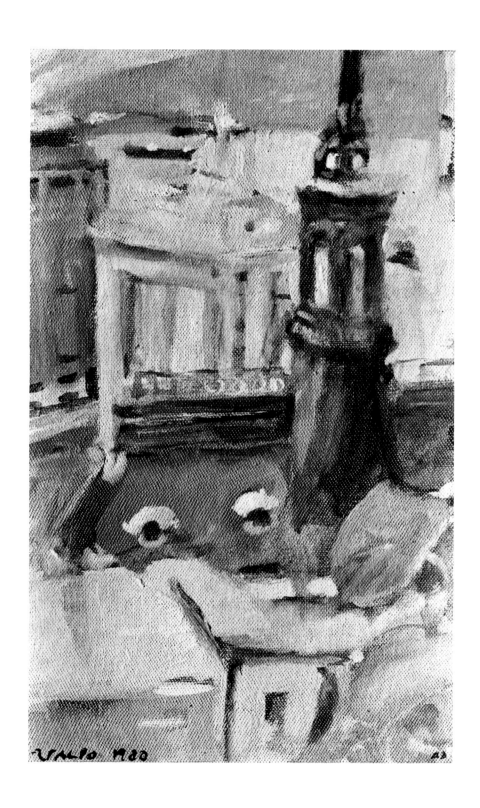

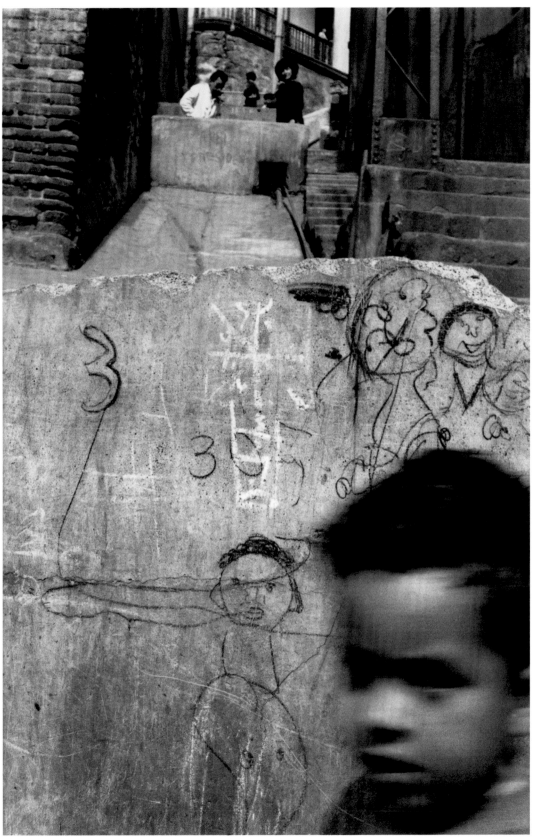

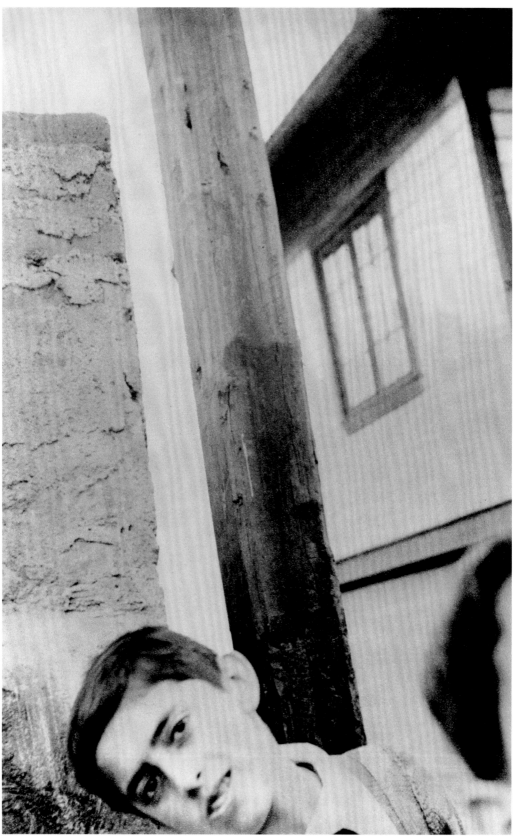

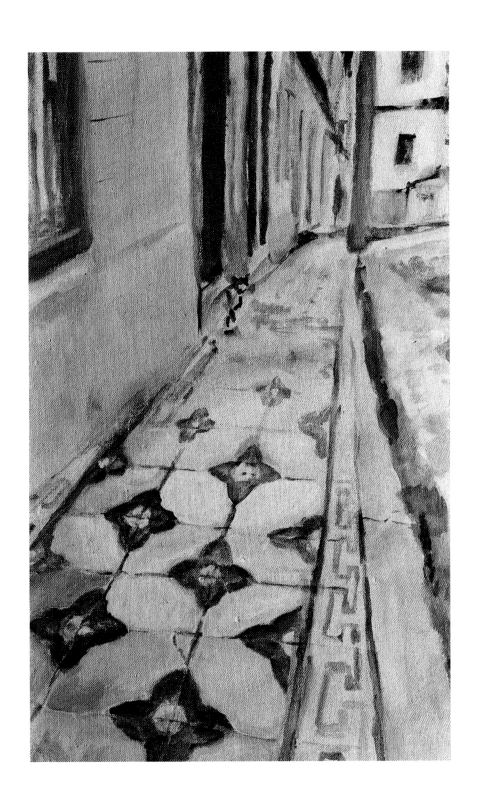

Undistracted,
surprised,
enyojing the li-
ving sculpture
of reality.

a glimpse!,
you stop.

you have the
entrance, the
veil is out.

33

Like a child
in front of a
buterfly, slow-
ly, you move,
not to loose
the frail,

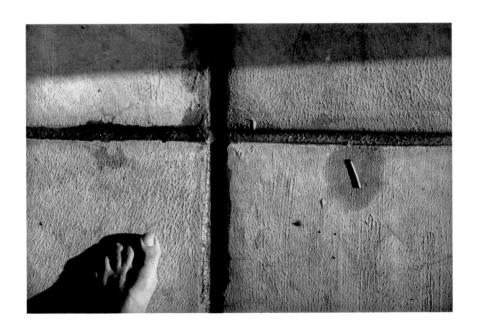

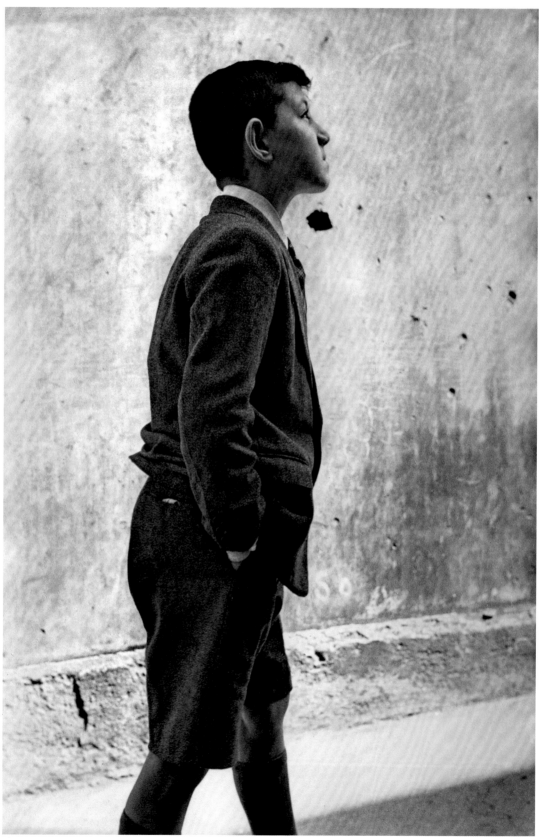

35

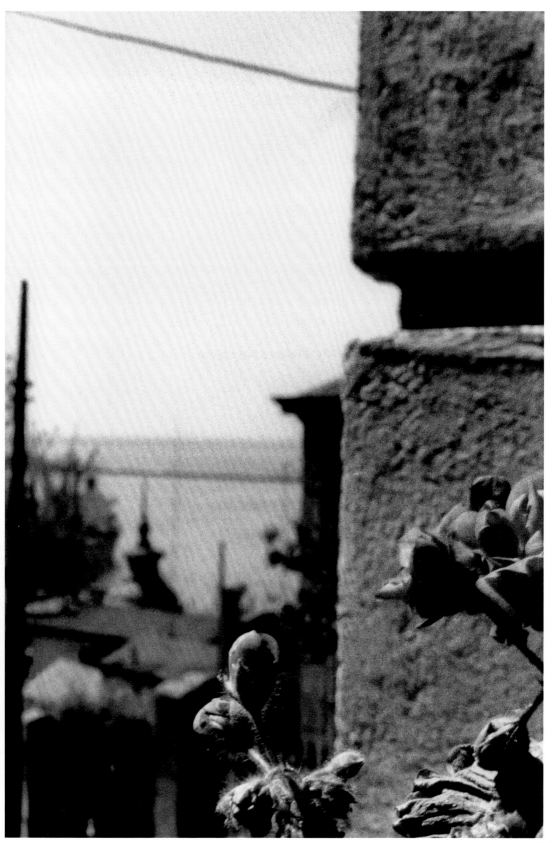

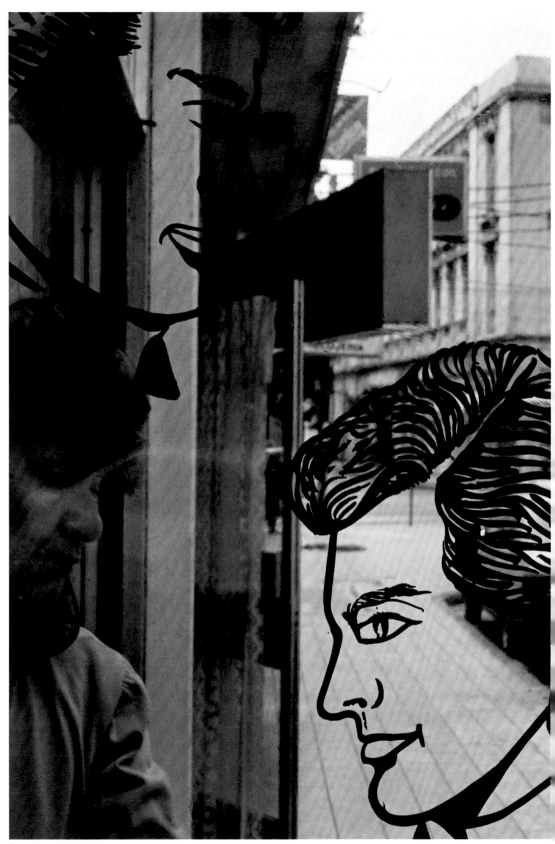

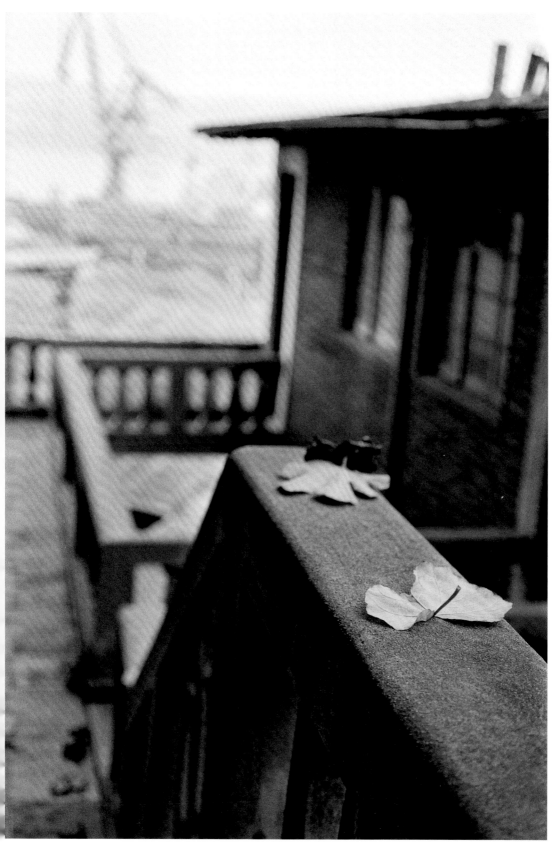

horizontal,
vertical,
.. contem.
plation.

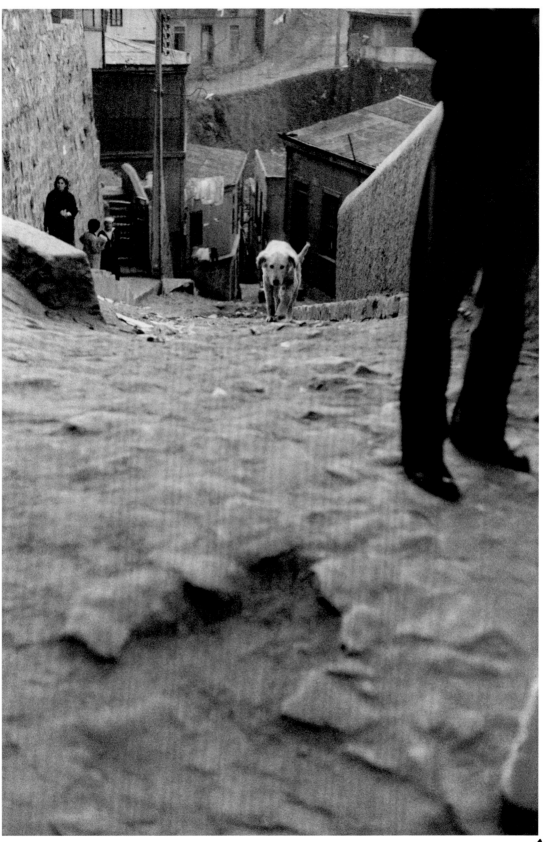

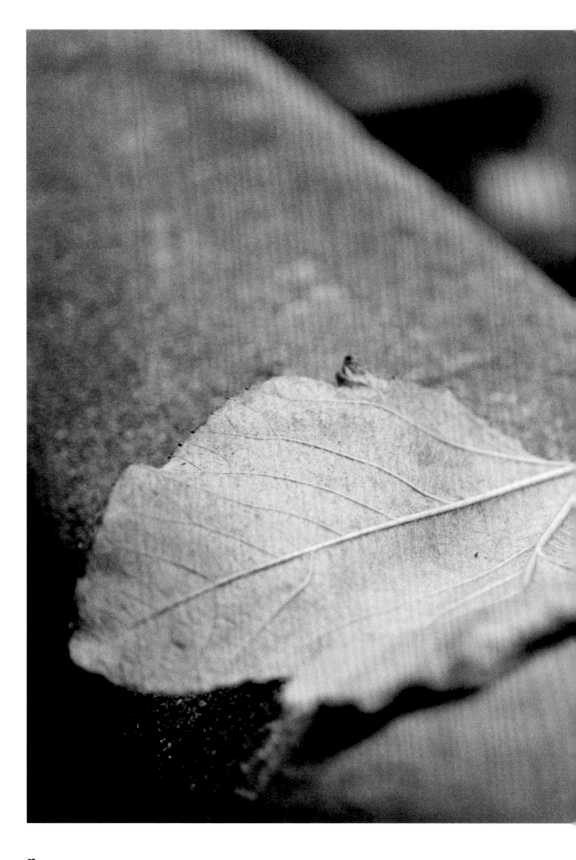

41

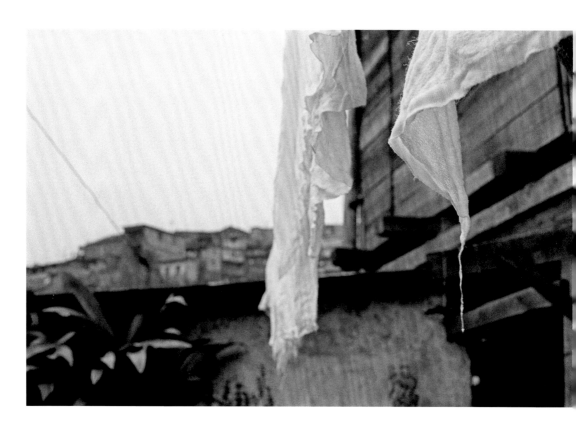

43

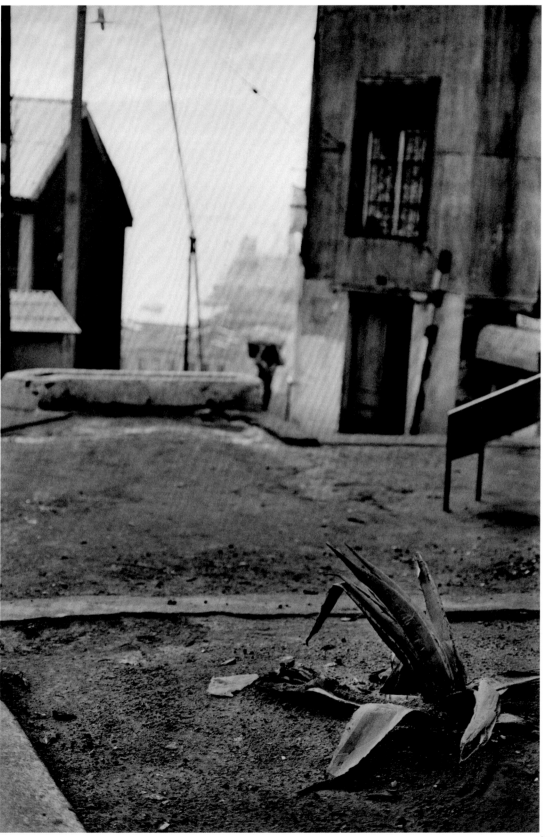

The door opened.

awoke in the

eternal,

beauty .

Slowly,

vertical,

horizontal,

with infinite

care ;

attention ,

organising forms,
as when ente-
ring water,
or the sun,
 .. enter the
divine.

You have cros-
sed time,
into the new,
(into the now);
life is renewed.

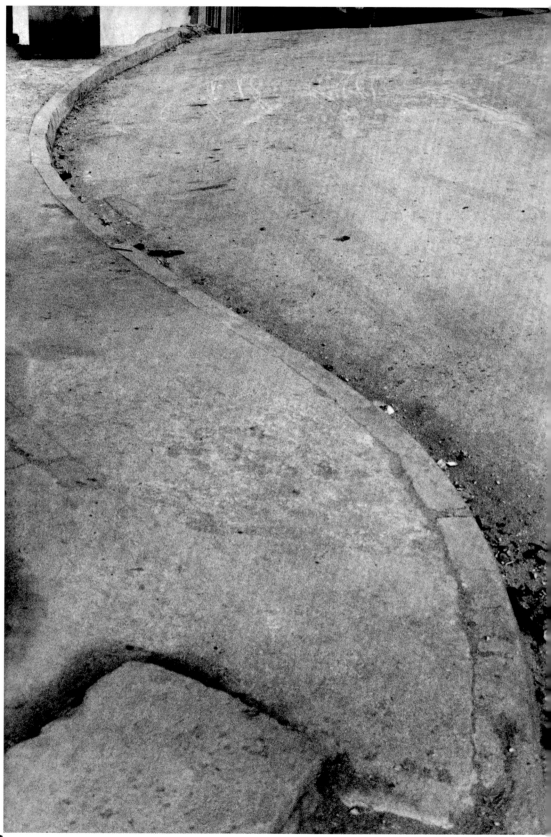

45

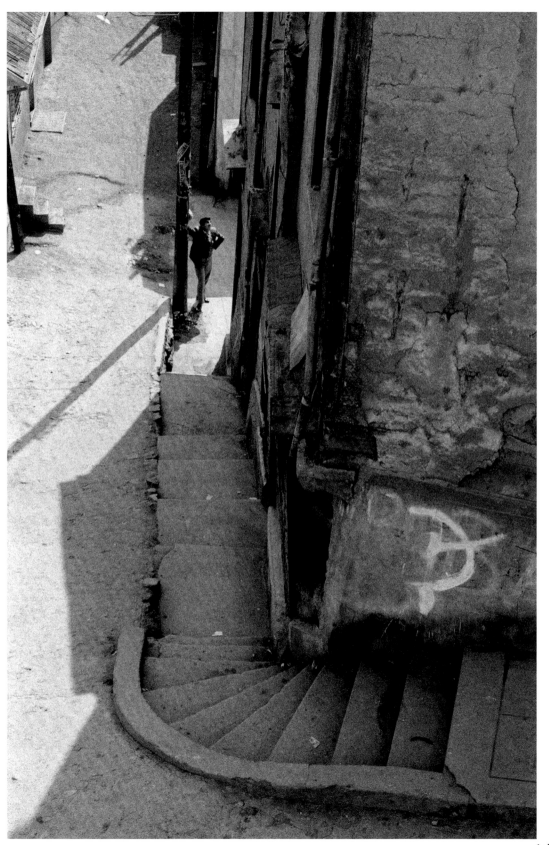

.. opening
the gate of
time,
with geome-
try .

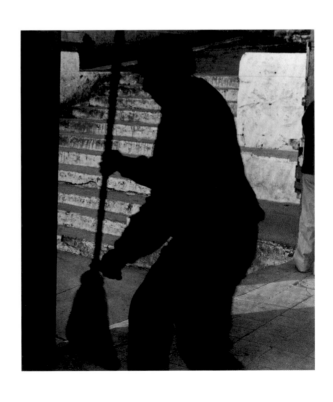

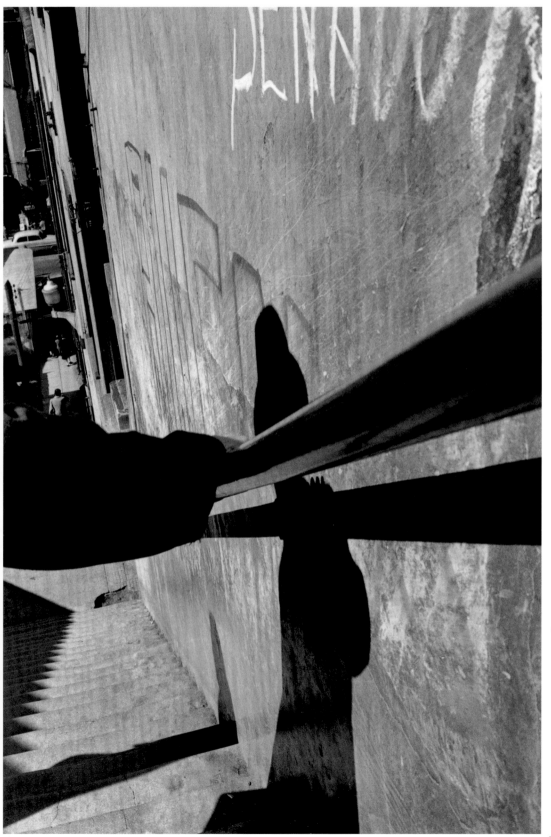

48

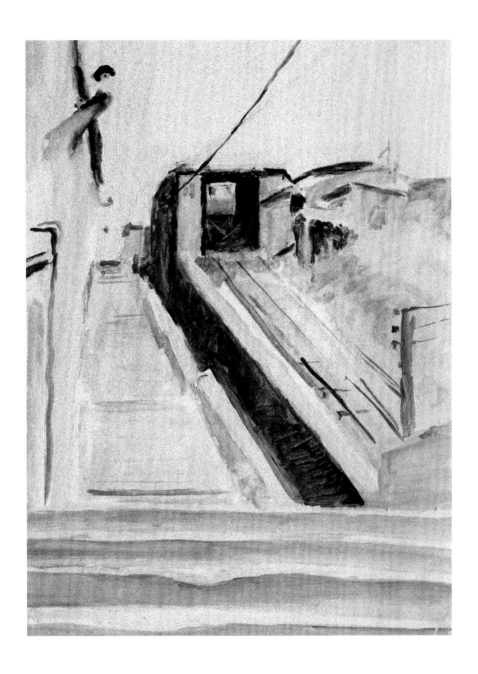

49

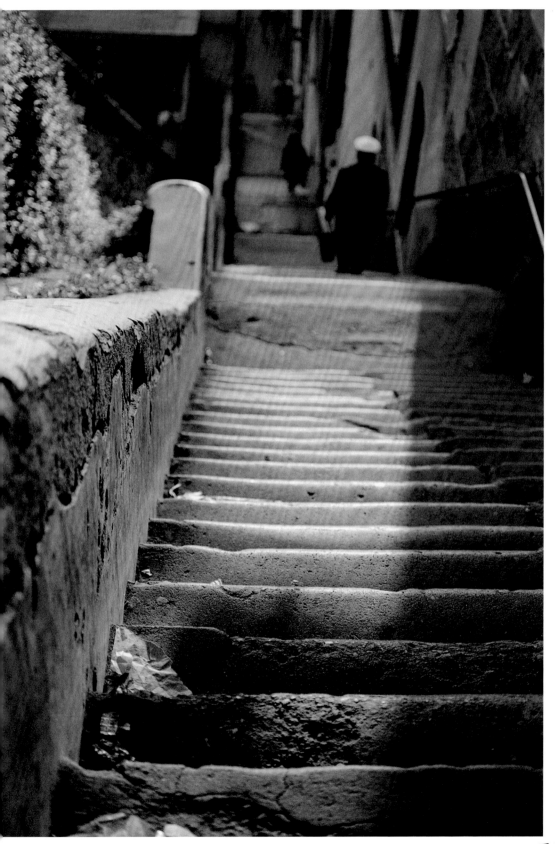

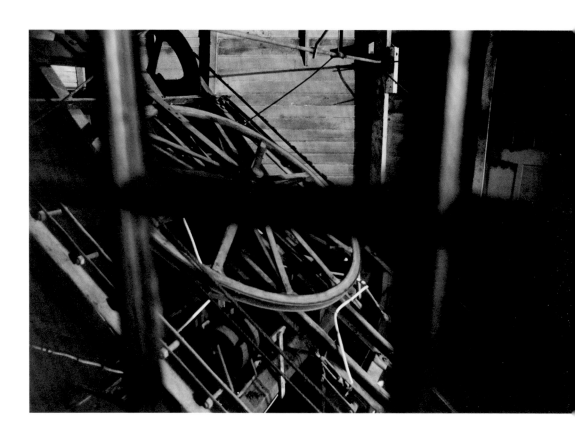

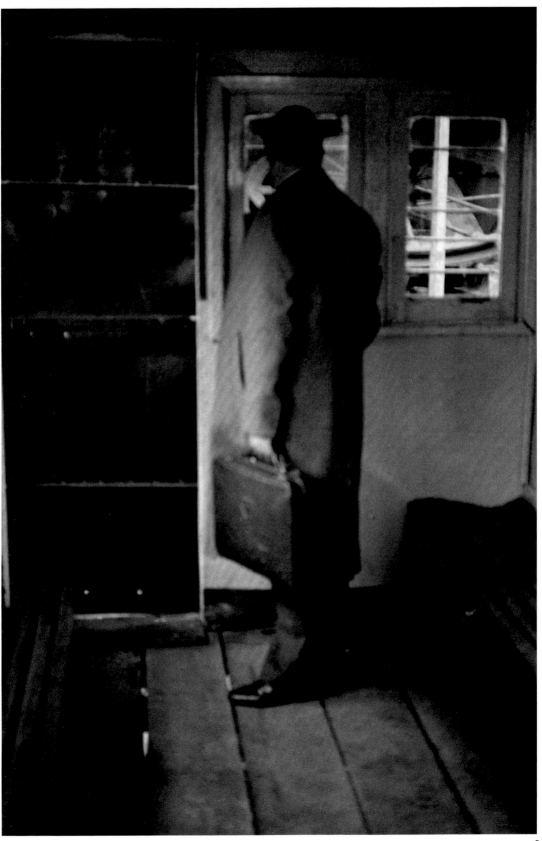

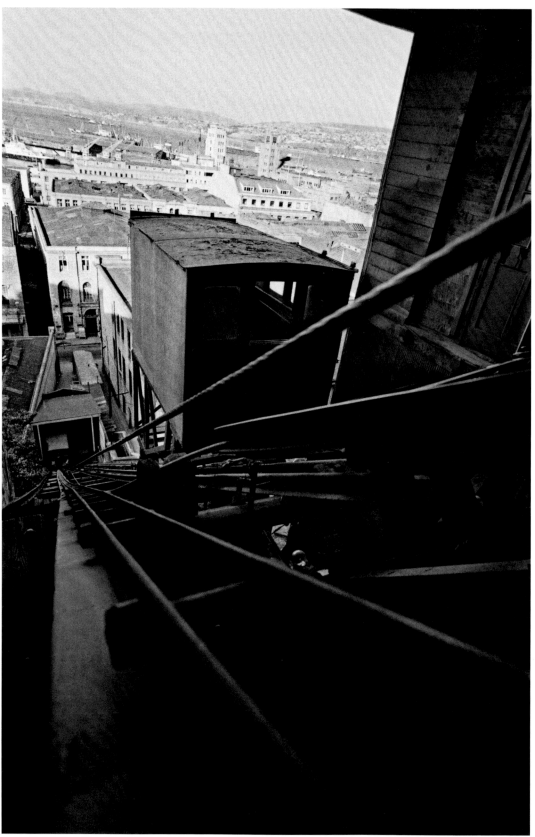

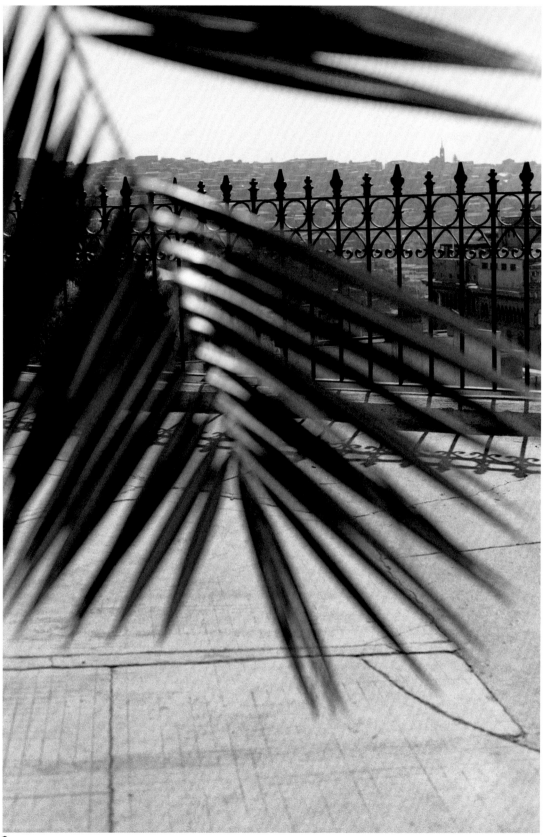

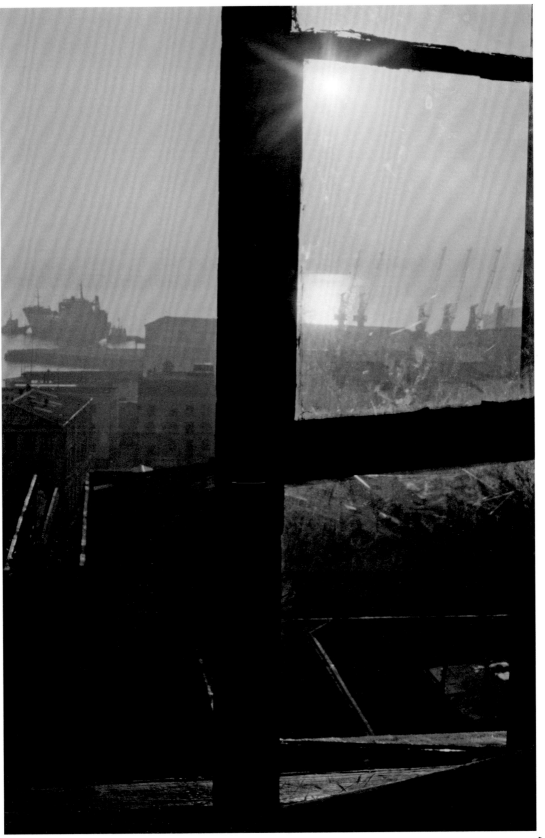

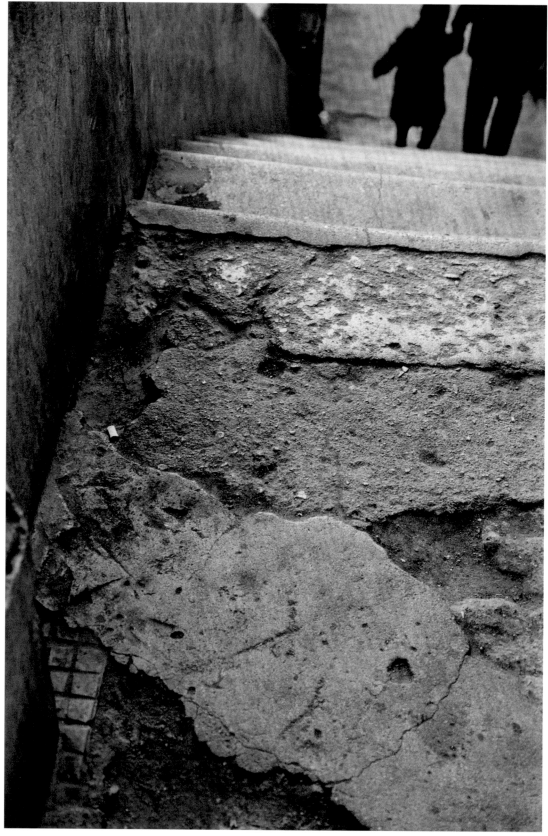

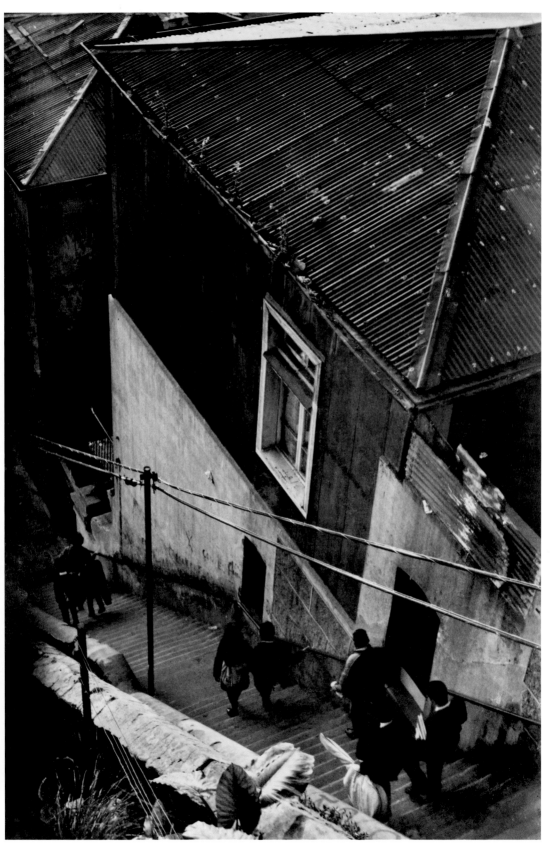

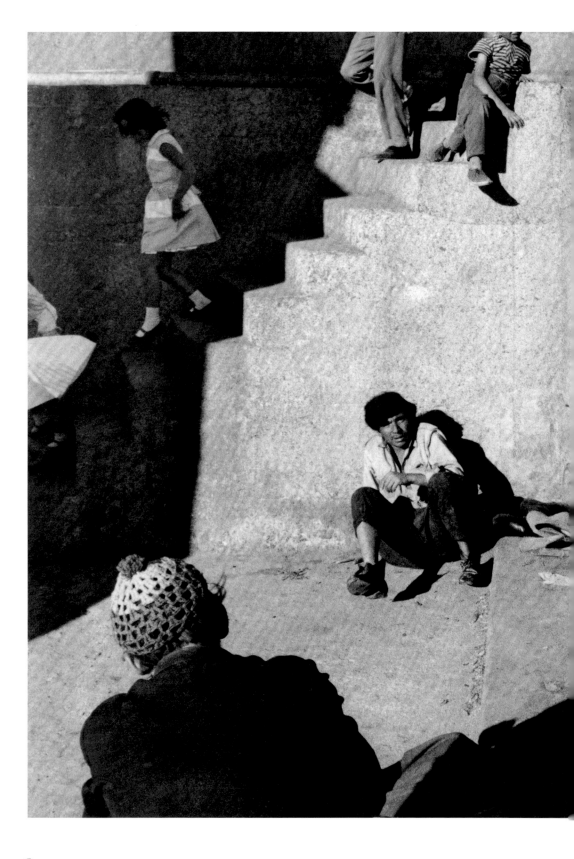

59

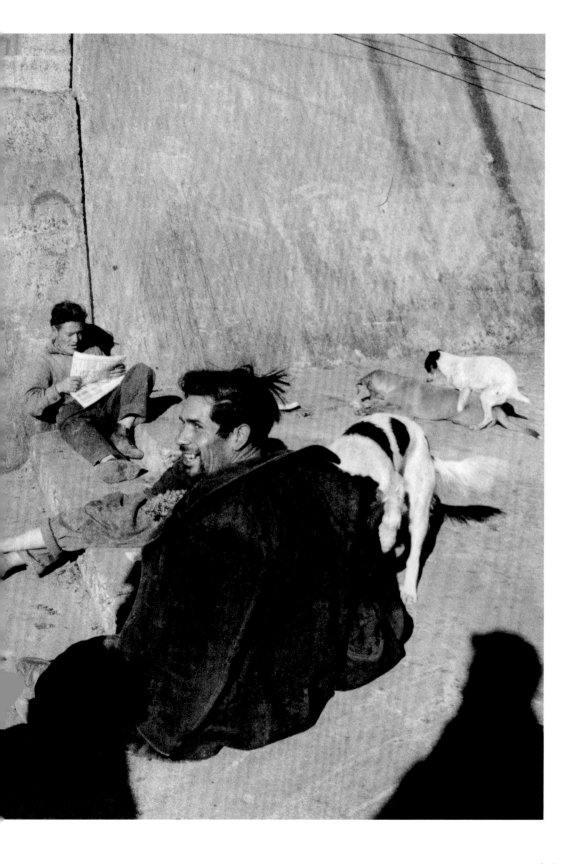

60

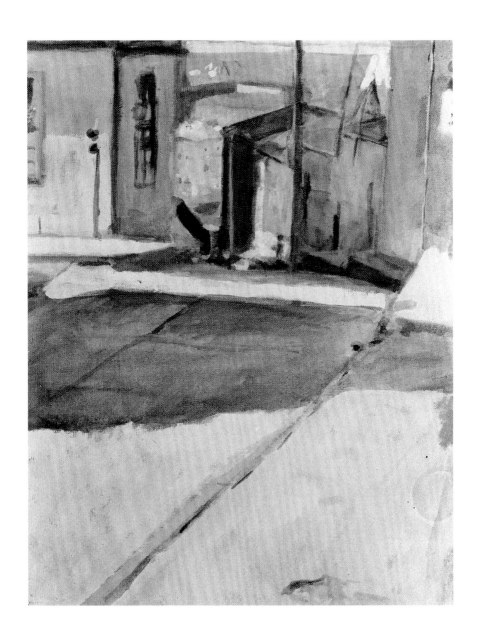

61

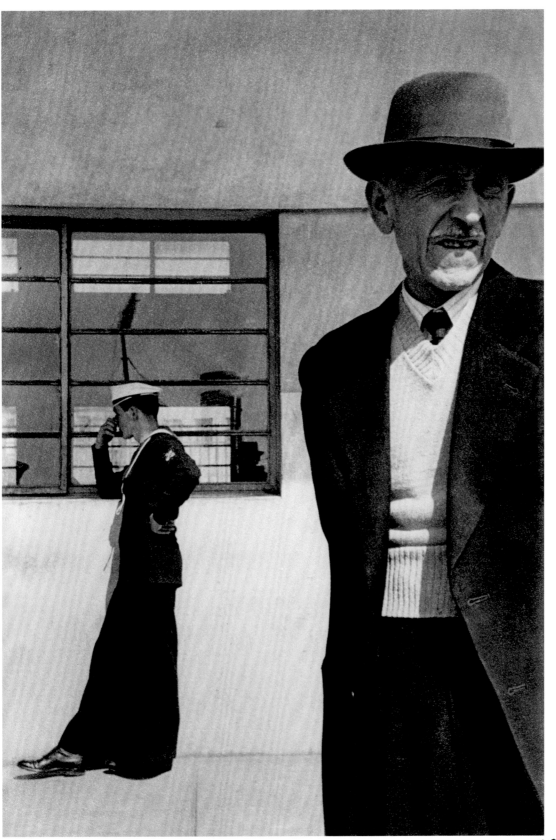

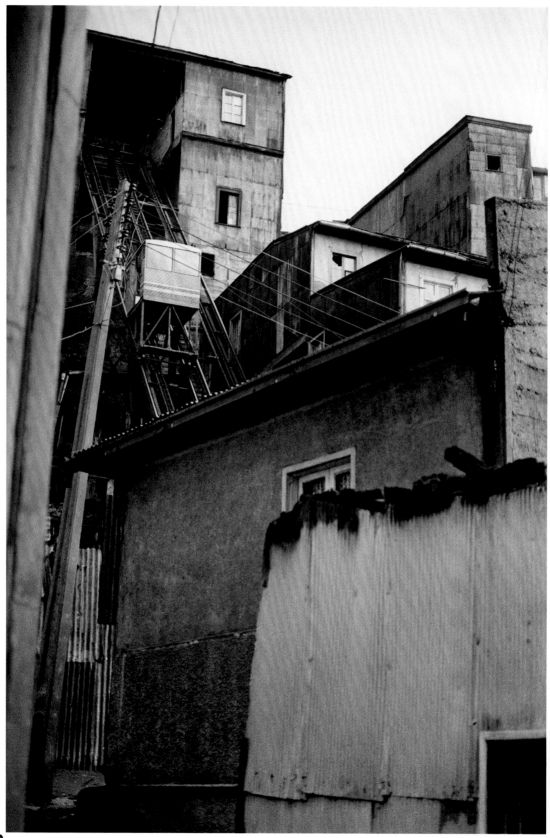

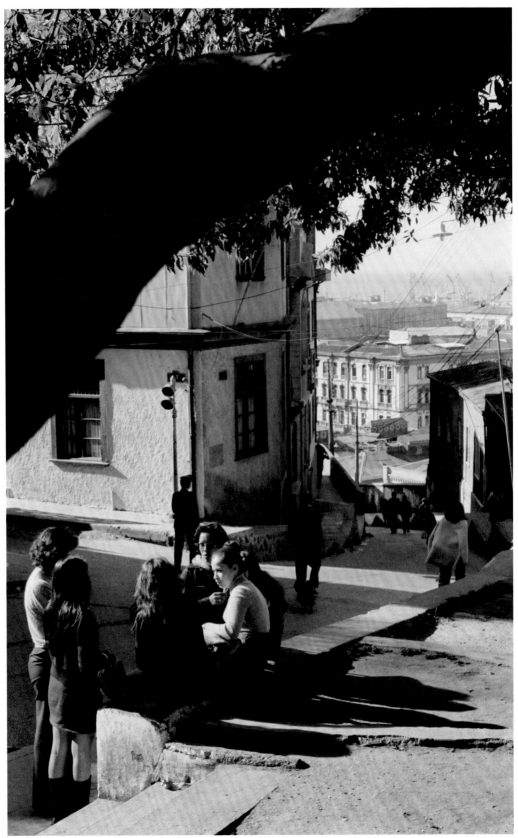

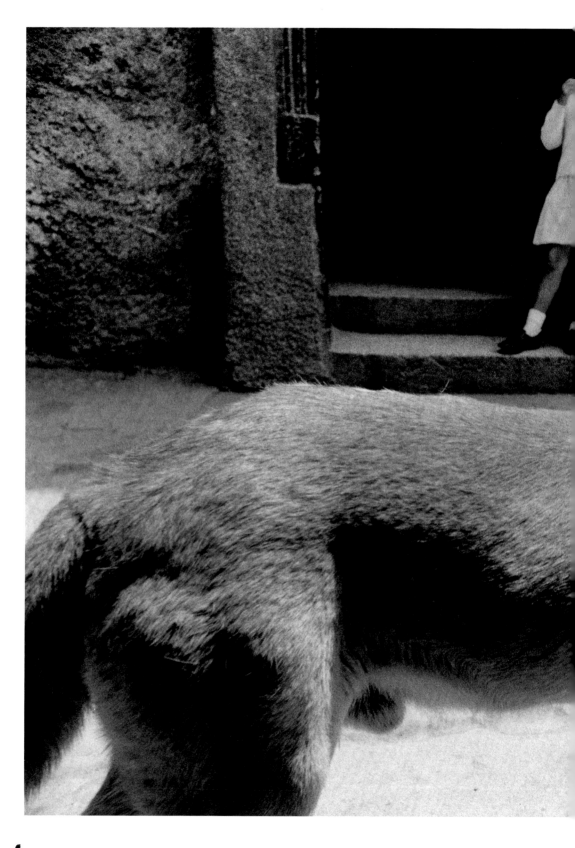

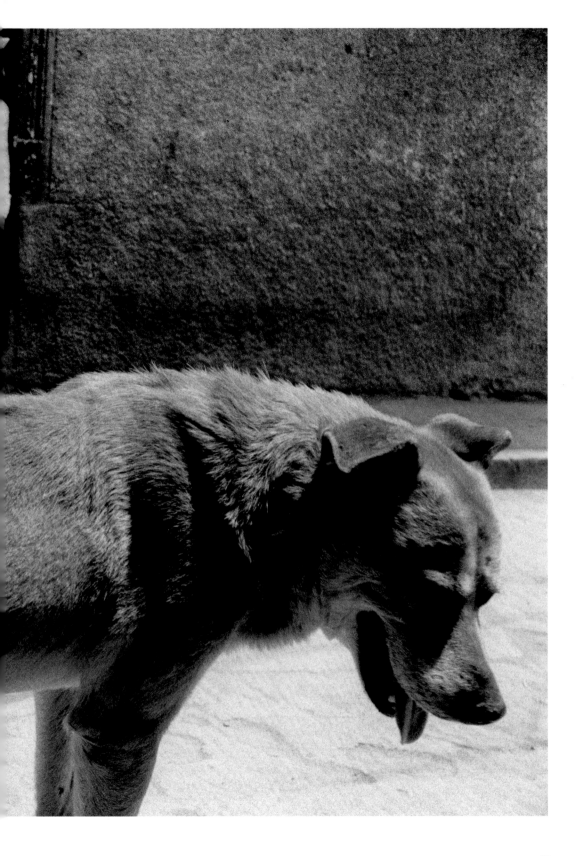

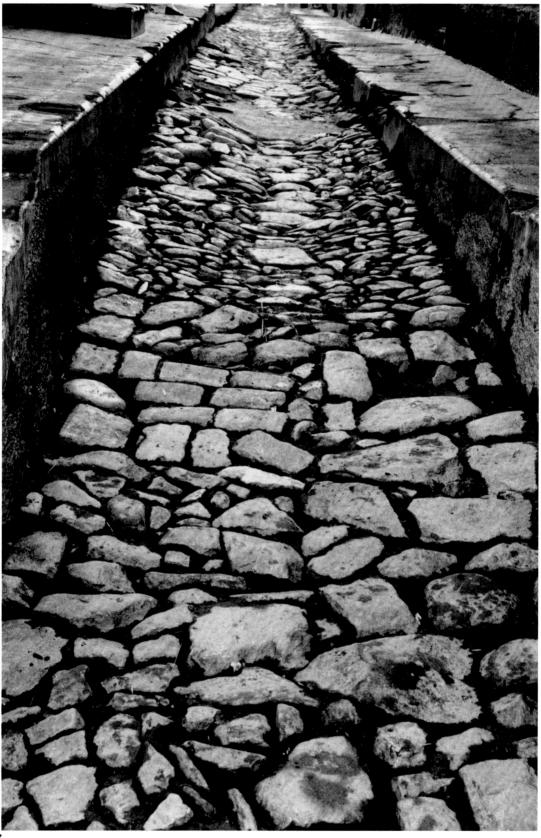

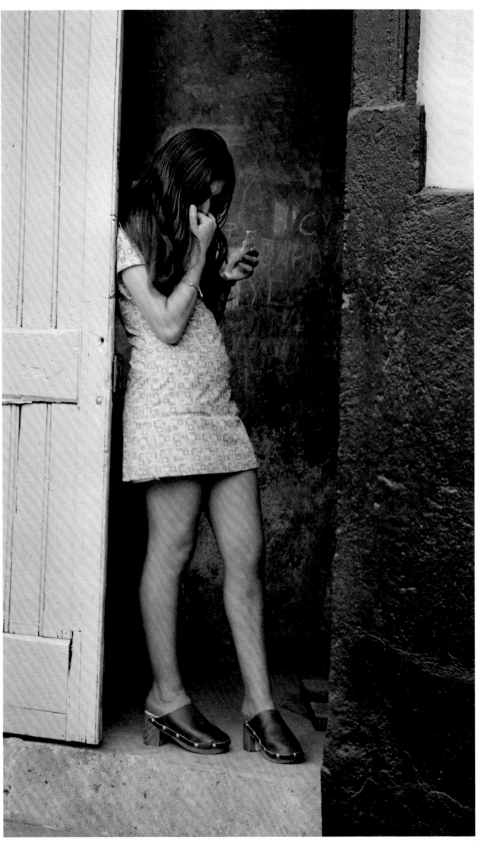

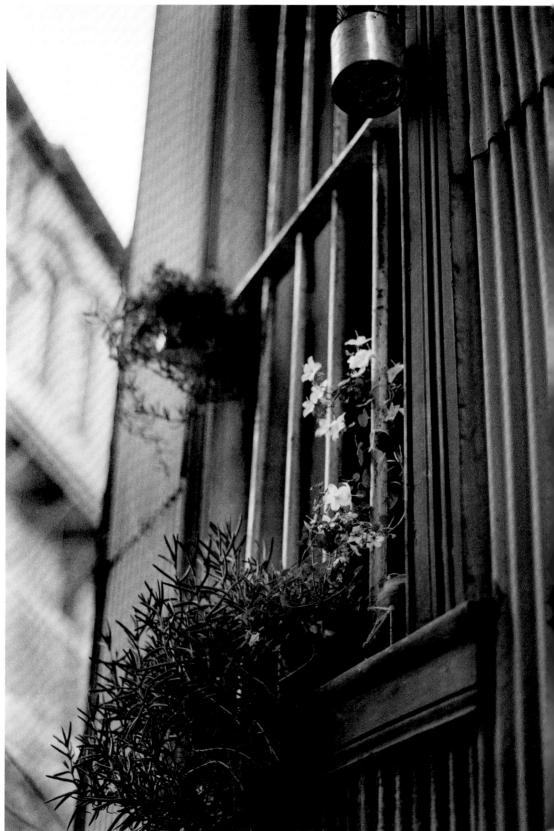

69

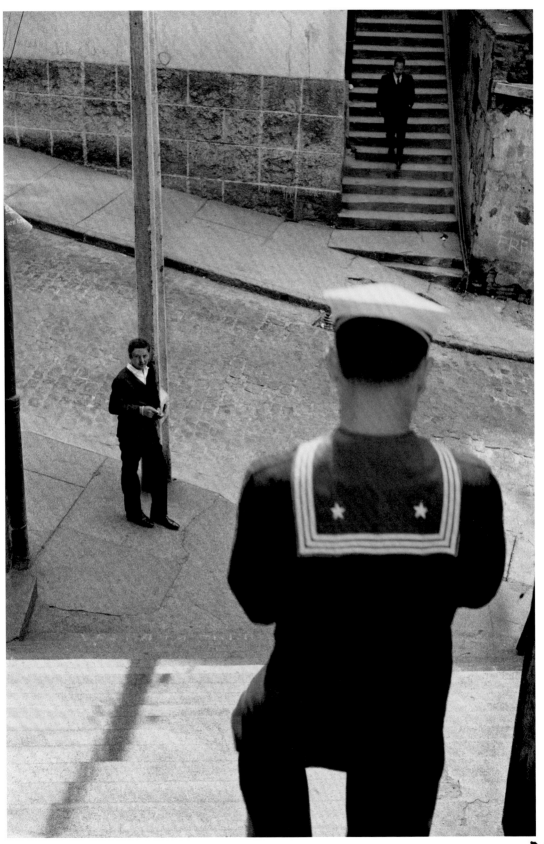

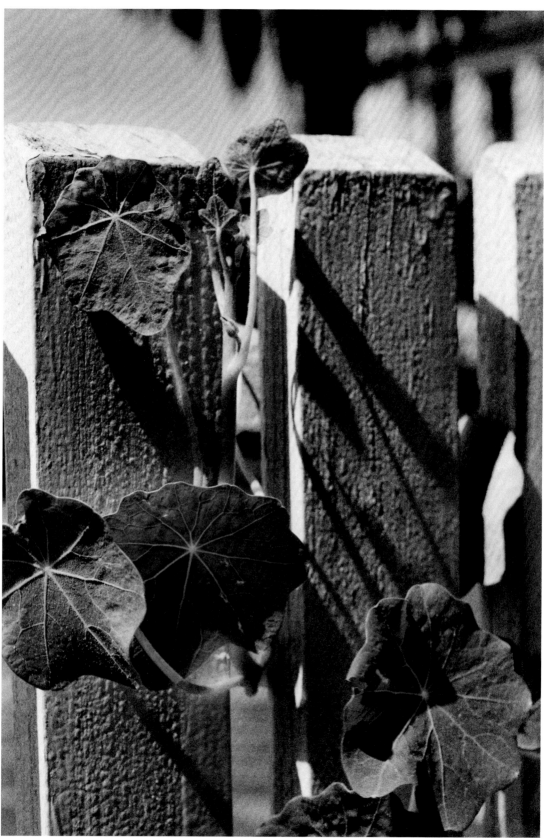

71

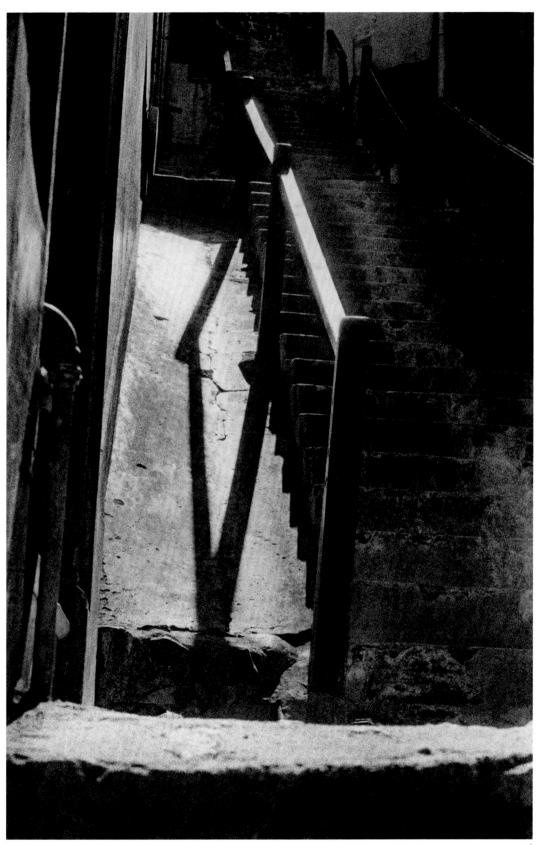

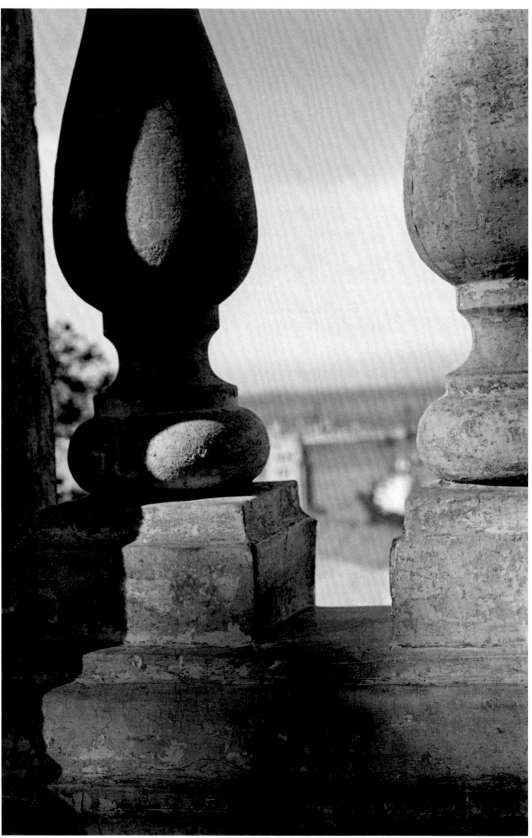

73

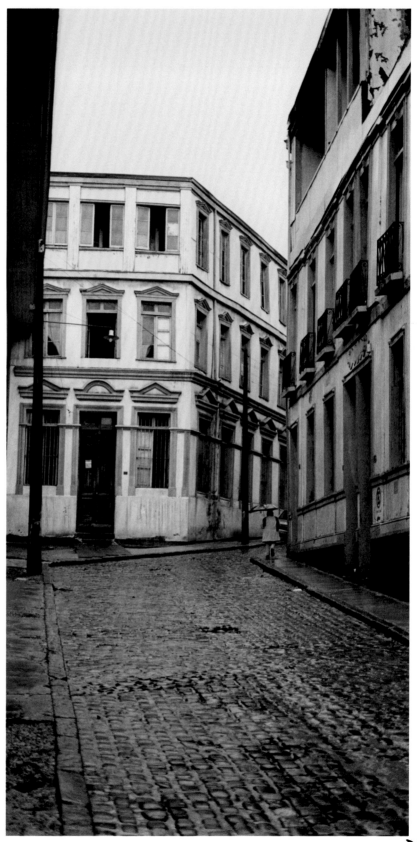

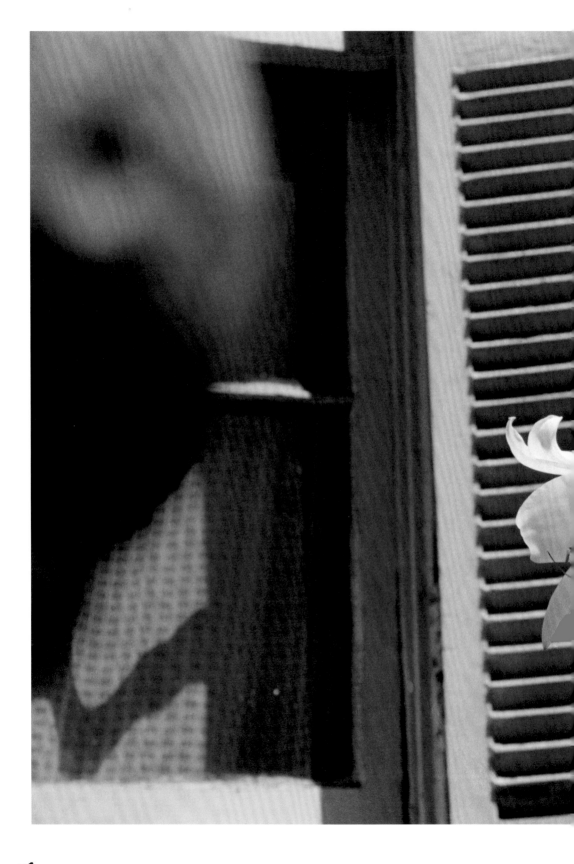

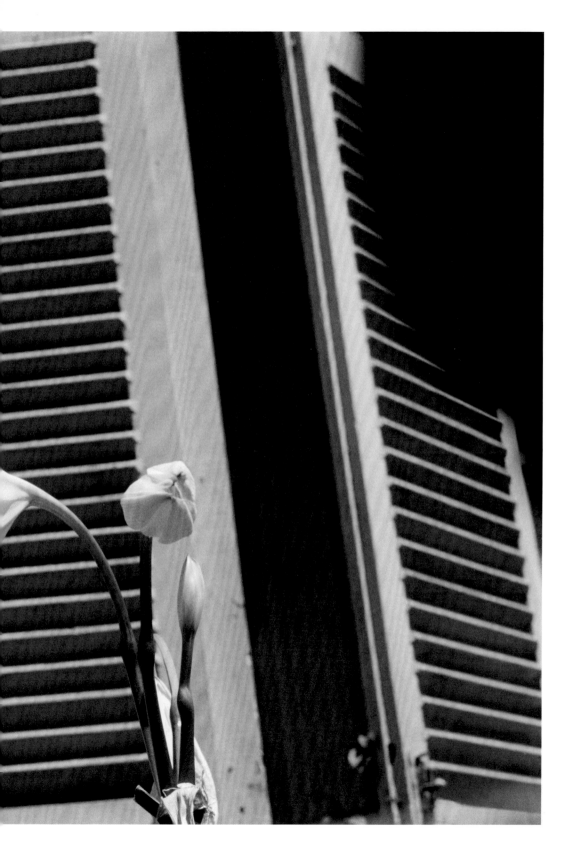

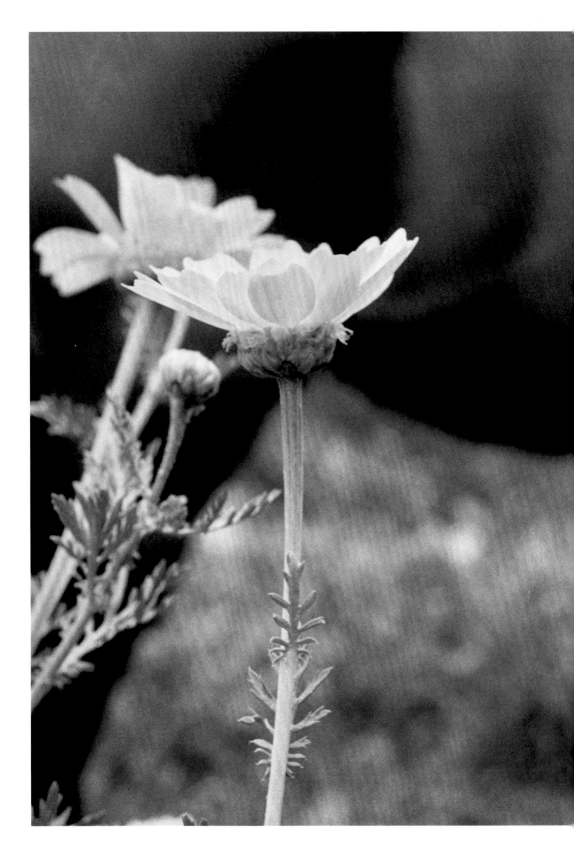

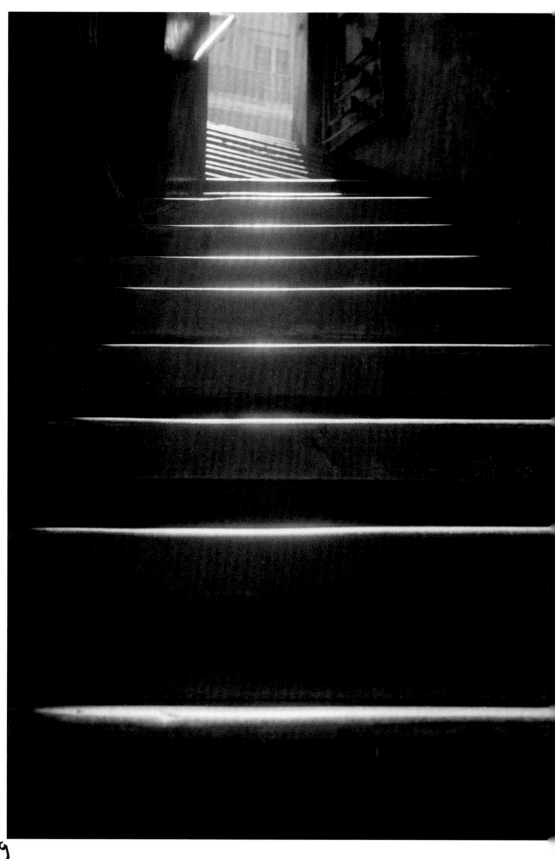

79

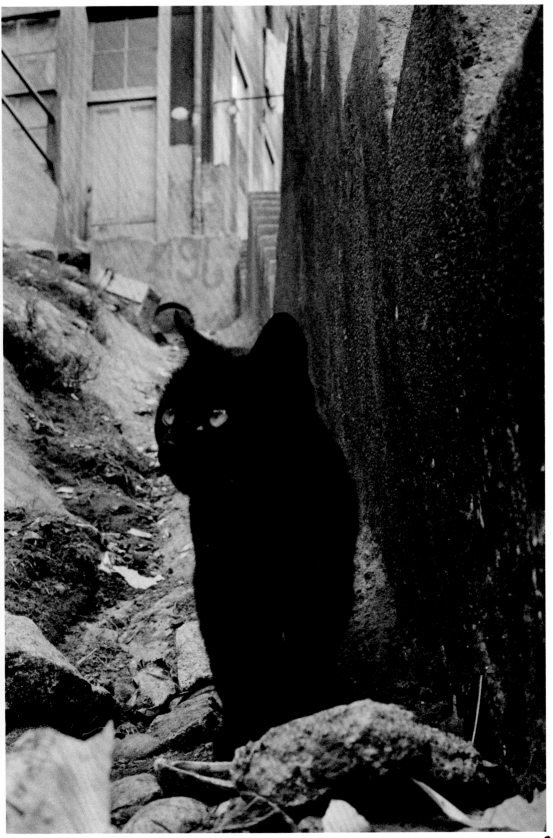

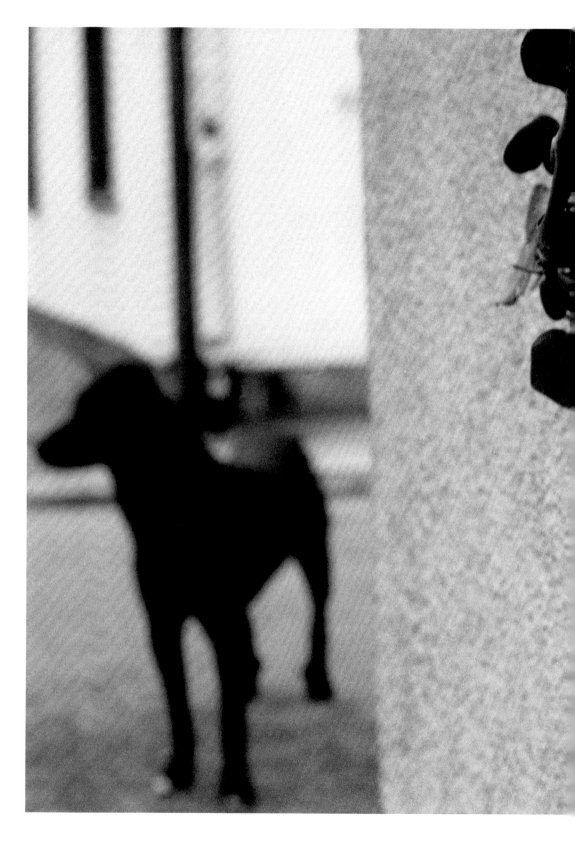

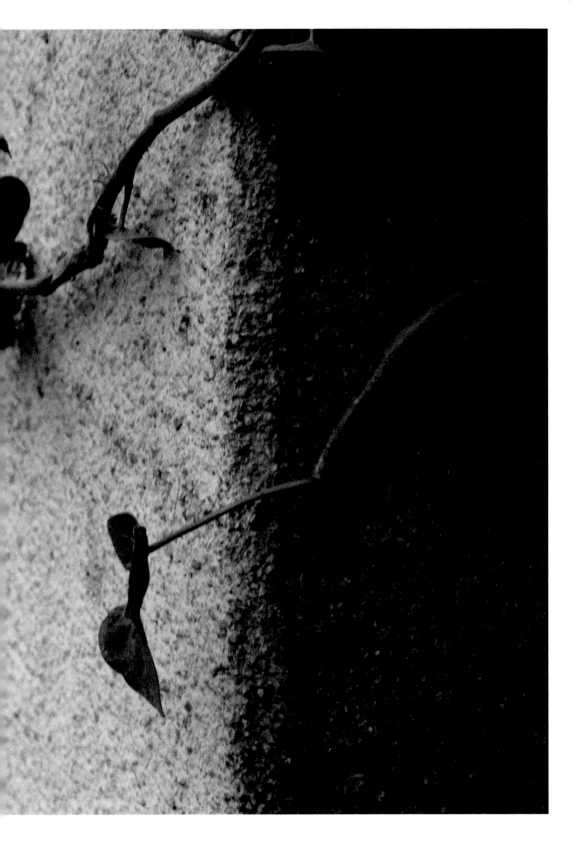

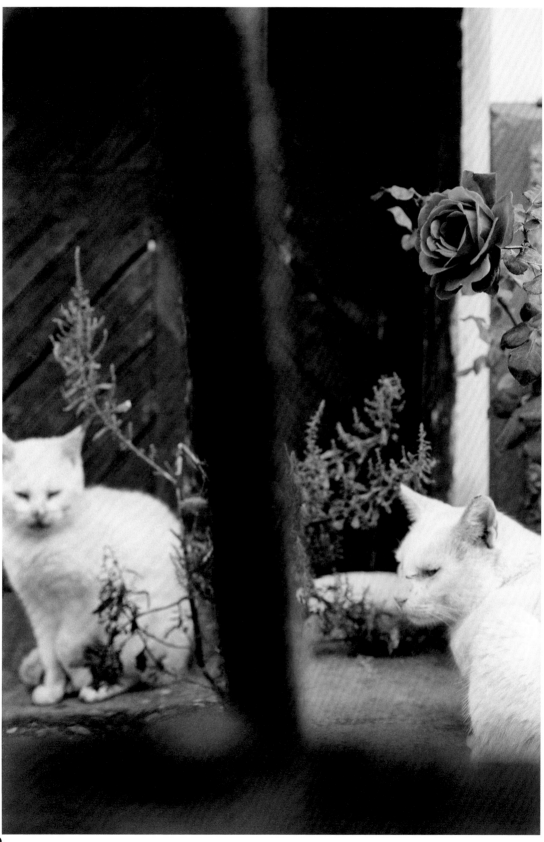

83

HUMAN
SCALE .

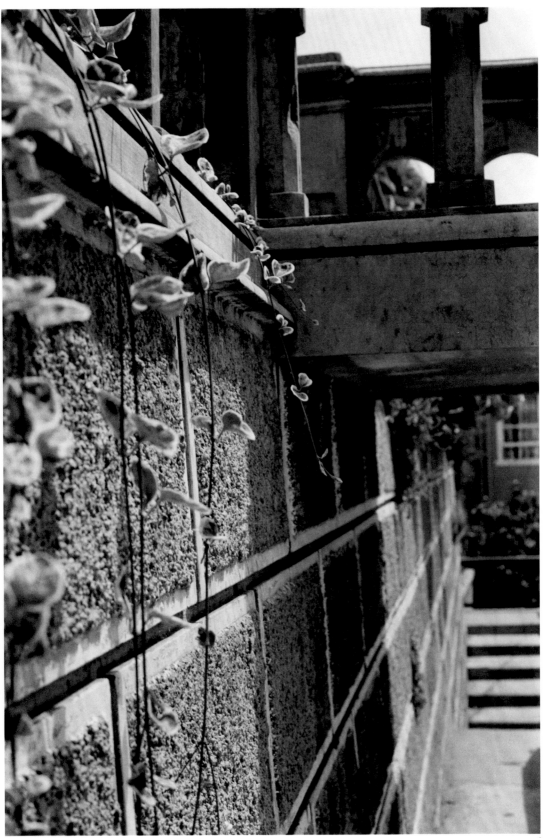

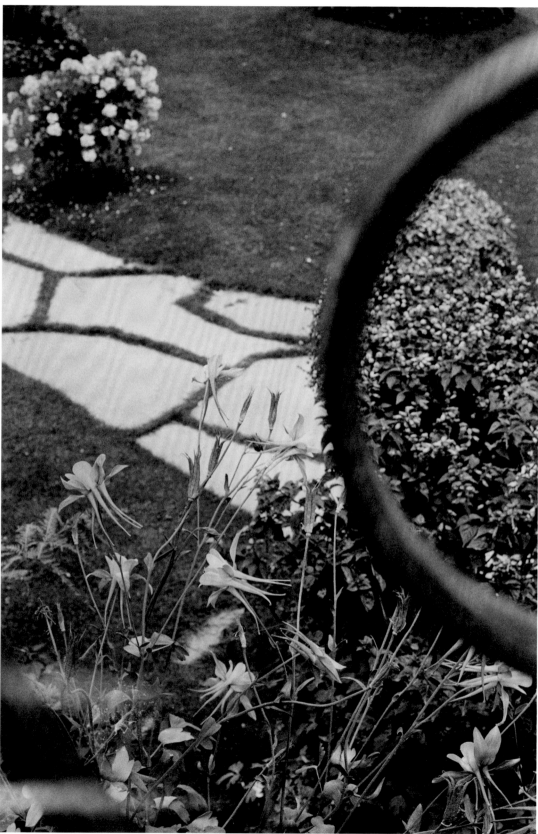

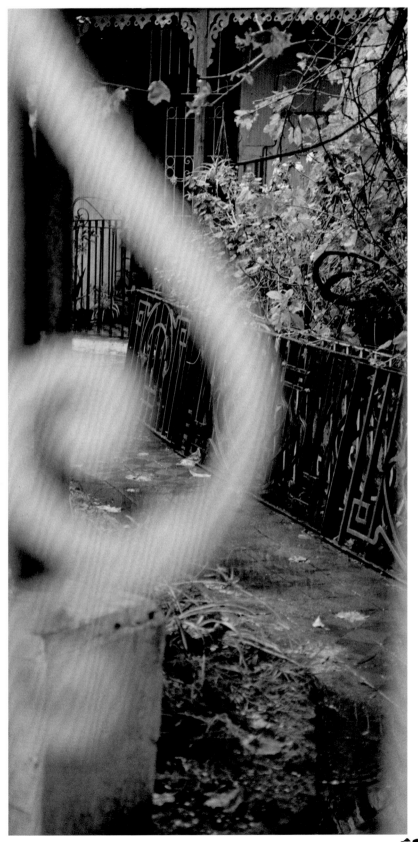

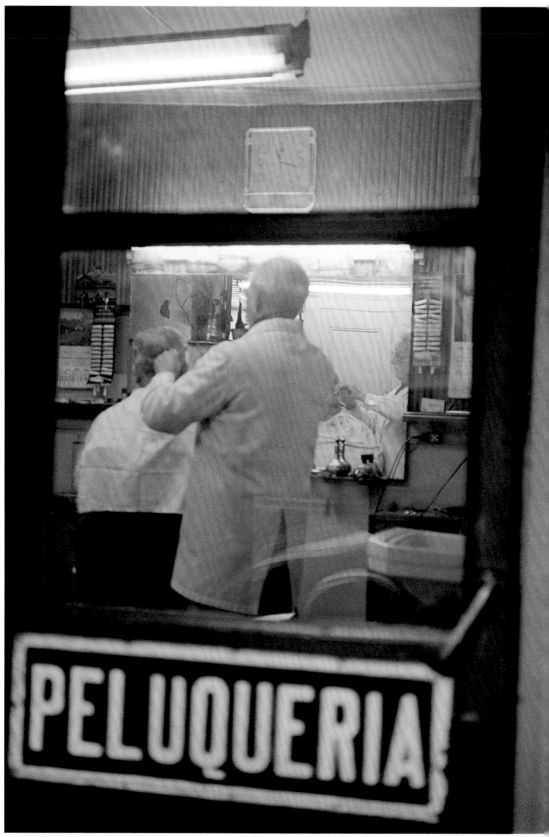

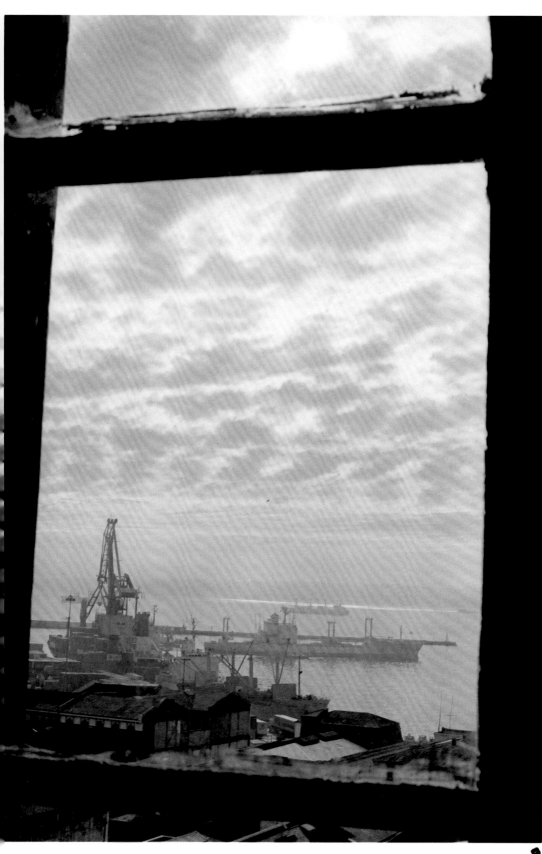

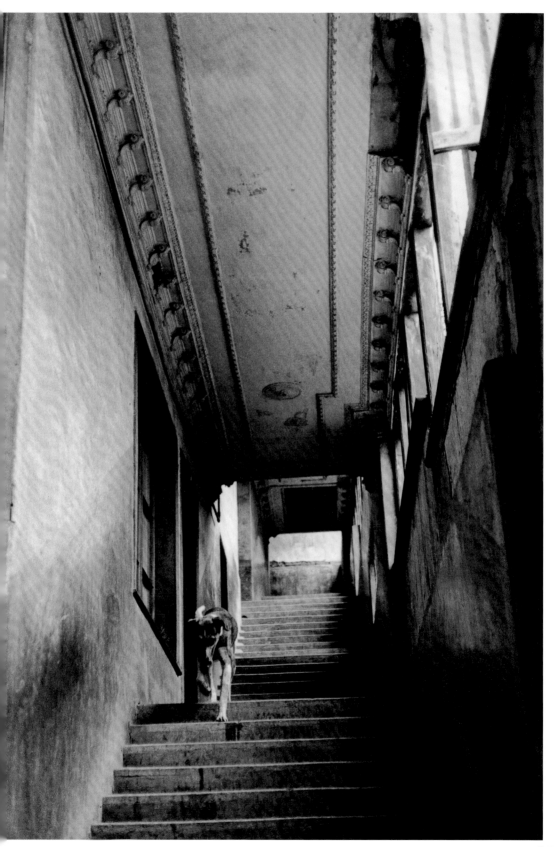

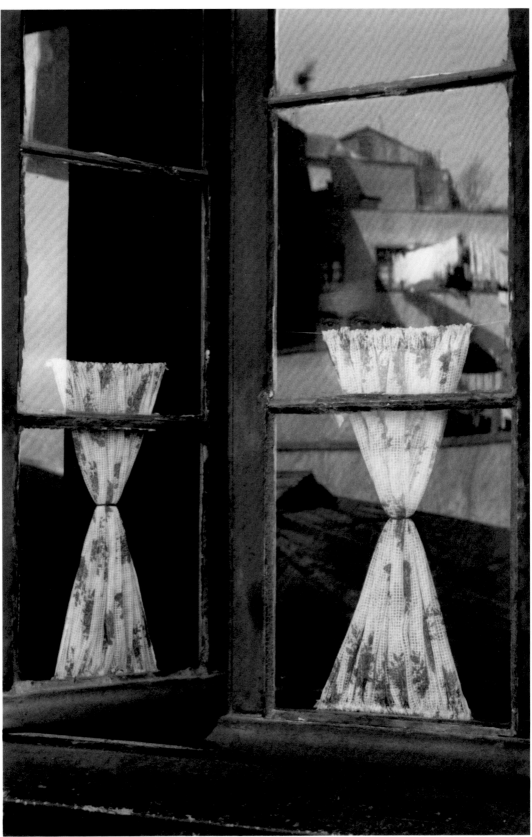

93

FEW
PEO-
PLE.

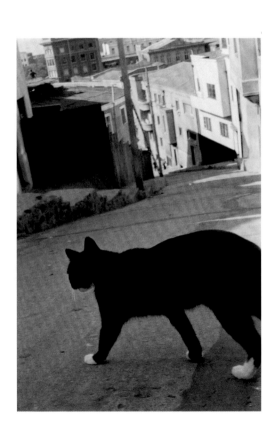

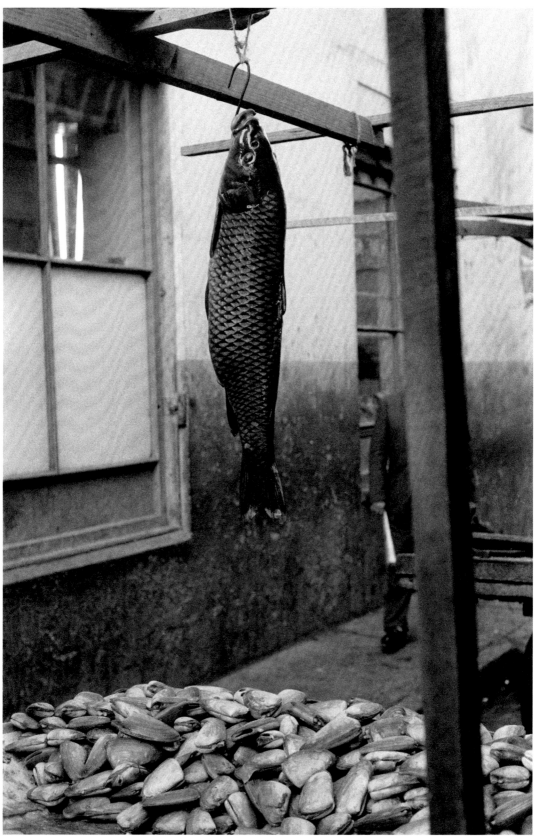

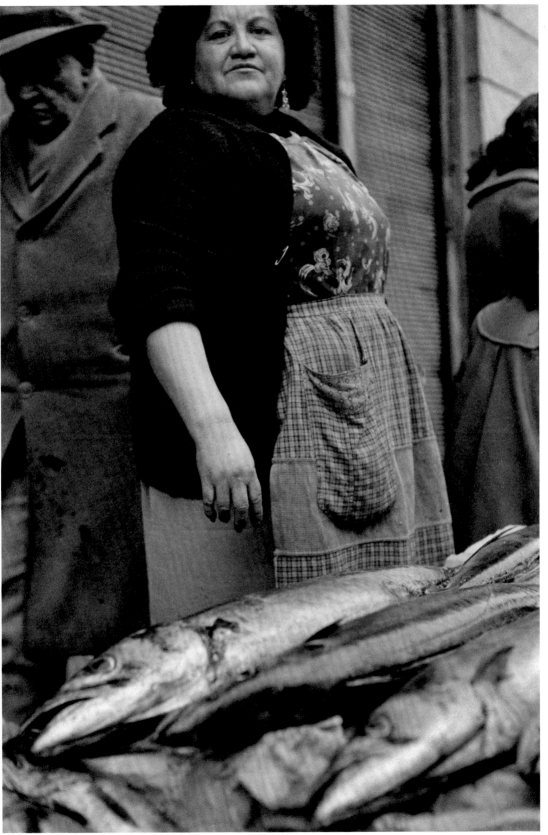

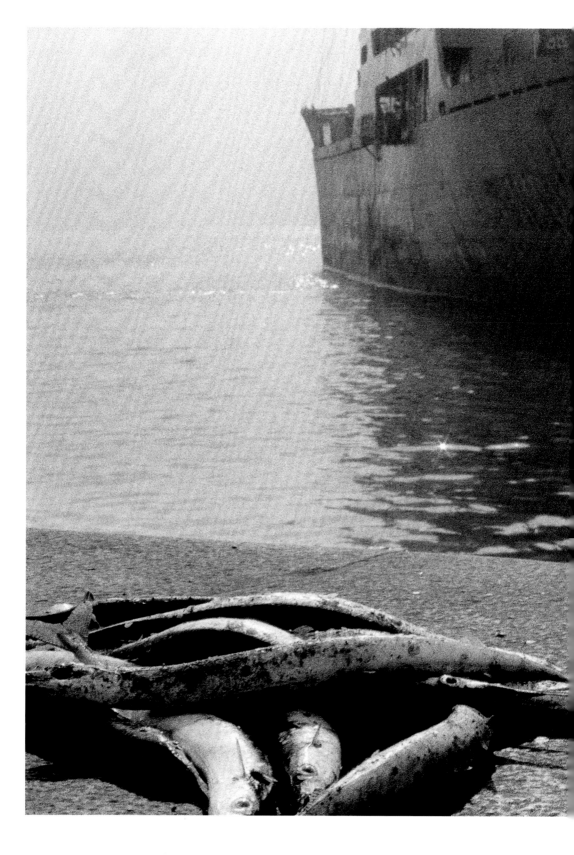

97

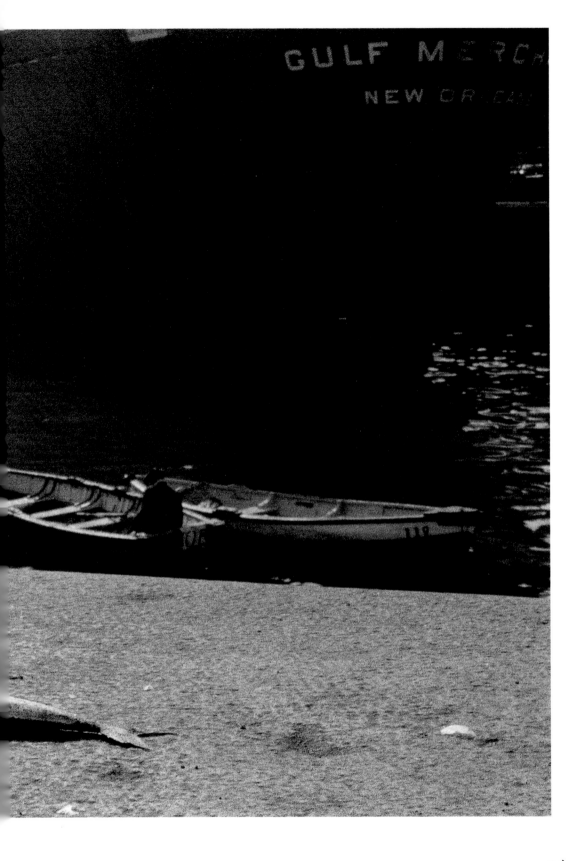

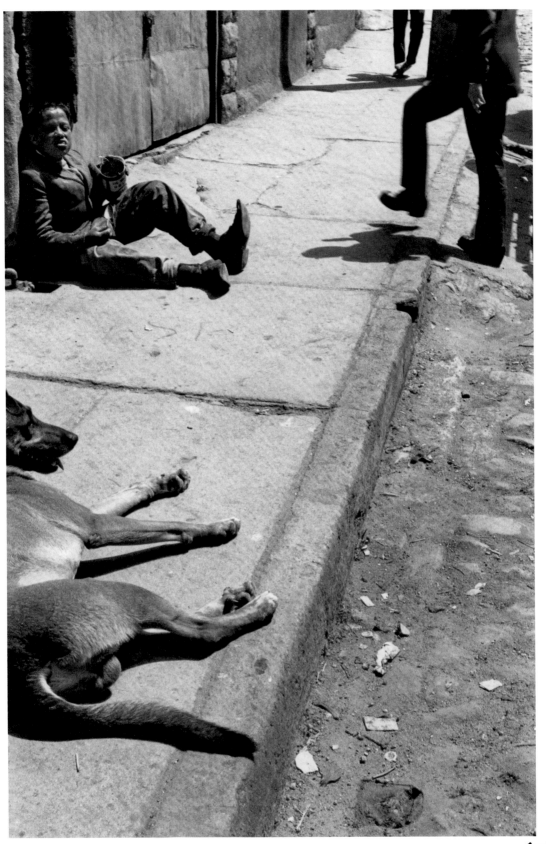

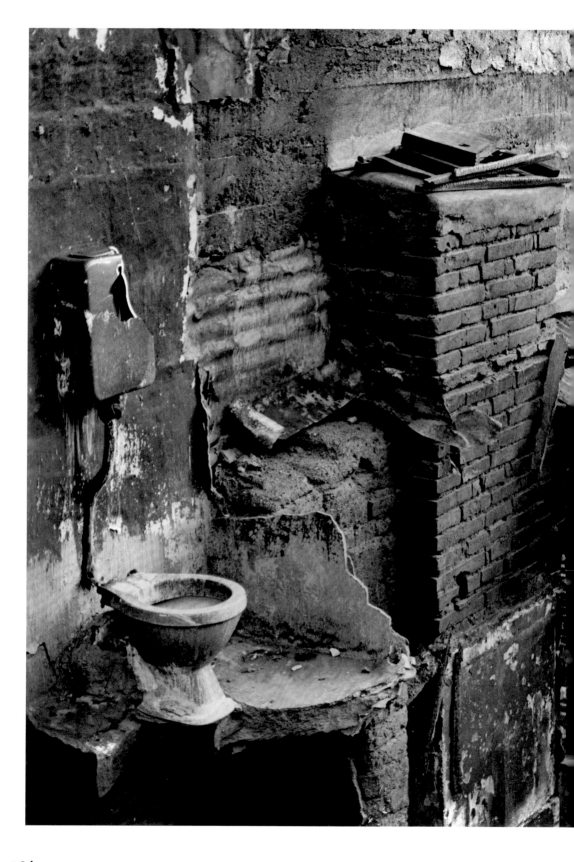

101

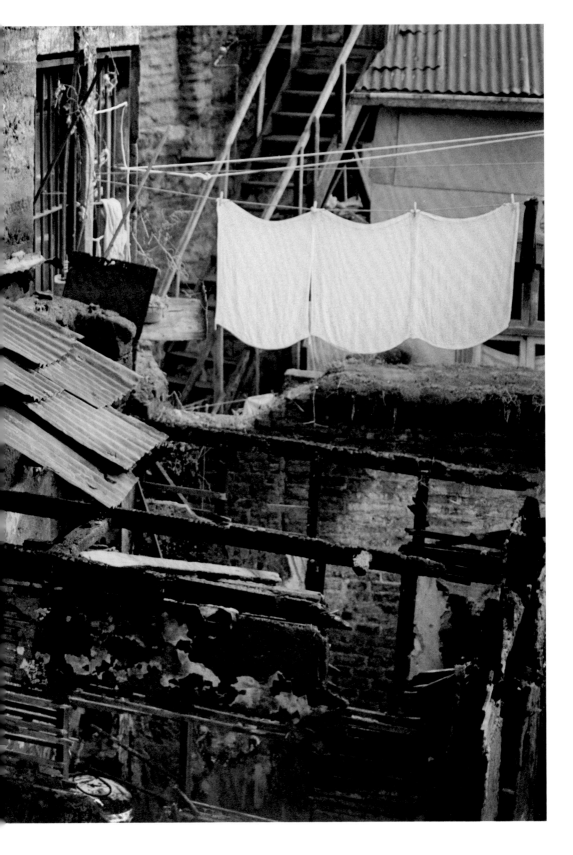

REENCHANTING THE PLANET.

● Valparaiso, being one of the most poetic places in the planet, is geting destroyed. By abandonment, poverty, and lately by crime.

Abandoned, as most good things on earth. Destroyed.

With our attitude of predators, (businesses), and parasites, (living on taxes), we have lost love for reality, for life. And we are destroying all there is that has beauty, harmony. (WITH SCIENCE AND TECHNIC

Our attitude can be corrected with YOGA, VOCATION, and CRAFTS. Coming back to reality, with sense, love, care, and awoke. (SATORI).

That can be achieved with an objective education for adults, globaly. Unesco program.

IF WE LOVE AND TAKE CARE OF THE PLACE WE ARE iN,
WE ARRIVE TO WHAT WE ARE LOOKING FOR.

● The Municipalidad de Valparaiso, could undertake the task of recovering and keeping in good health the city; forever.

The Department of Architecture of the Catholic University, in Valparaiso, has great love and understanding for the city. They could undertake the task; forming schools of carpenters, masons, painters, gardeners, etc Of recoverers, and preservers.

Would mean labor.

At the long run, it is the best investment. People woul come to visit the city, for it's beauty. Leaving money in hotels, restaurants, shops, craftmen, taxis. That would mean labor. (Without destroying what is good).

That could be an example to be followed all over the pl net. Recover and preserv. all the marvellows plac and occupations, there are.

INSTEAD OF DESIRING NEW THINGS, WHY DON'T WE PRESERVE WHAT WE HAVE?

103

The INCA ROAD, could be reconstructed, and preserved. With it's tambos, construct local museums, recover traditional crafts, agriculture, inns for the visitors.

It would be the most beautifull paseo in the planet, in the crest of the hills, (where waters divide). Looking at the stars in the night.

The road goes from Ecuador, to Chile, Argentina; through Bolivia and Perú, centered in Cuzco. (That is the size of Europe, more or less).

The most beautifull walk in the planet. Would be stable and good business for the region, and it's people, (without destruction).

RECOVER ECOLOGY. BRING POPULATION DOWN, (with anti-conception), GLOBALY. FAO PROGRAM. (No child, ever! be engendered without place and function).

INTERDICIPLINARY GROUPS, INTERRELATED. A technical administration of the planet, and all it contains.

Integrity achieved technicaly, with yoga.

Yoga be part of the formation of all profesionals, globaly. Unesco program.

The level of BUDA, (the top level in the scale of levels of consciousness), be achieved in the University, (and technical schools), as part of the formation of every student. Ending, in that way, our attitudes of predators and parasites.

BUSINESSES BE TURNED INTO SERVICES, (and cooperatives), under the order given by the Interdiciplinary Groups.

Frugality.

A CONVENT'S ECONOMY IS THE ONLY ONE THE PLANET CAN RECICLE WITHOUT DEGRADATING.

104

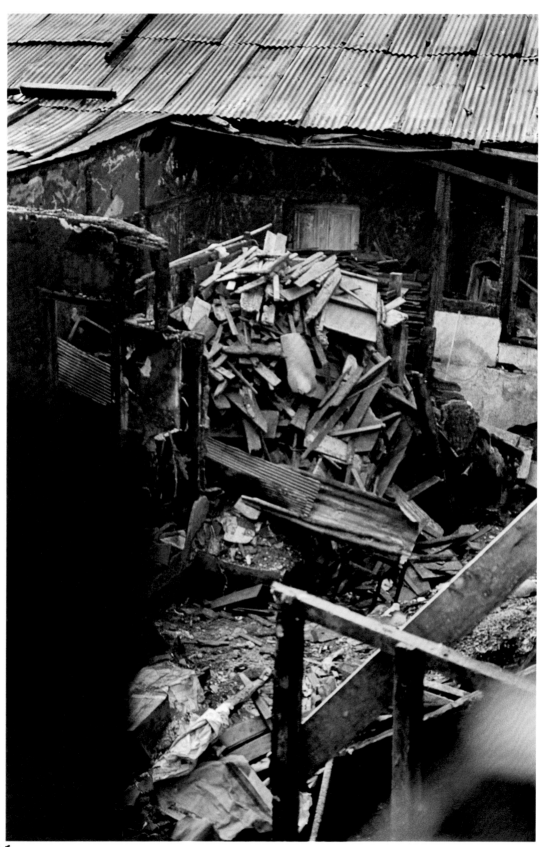

105

ARE LOOSING THE PLANET:

1. The Ozone layer destroyed, it's destruction enlarging permanently, and the products that destroy it are still produced.

2. The green house effect, that in 500 years could destroy life in the planet, and the gases that produce it, ar still thrown into the air.

3. Demographic explotion. At the beguining of the century there were only 8 cities with more than 5 millions inhabitants. Now we are reaching over 90, some having more than 20 millions, and population keeps growing. Ending in violence. In Rio they kill vagabond children permanently, while the Vatican blocks anticonception. Brazil being a catholic country.

4. 60% of the planetary forests have been eliminated, the rest goes in 40 years, and it is the renovation of the atmosphere.

5. Destruction of fauna by overfishing, and destruction of it's habitats.

6. Exausting non renewable resources. There is oil for only 40 years, at the speed it is being used, and all modern world is based on oil, from agrarian and pharmaceut cal chemistry up.

7. Pollution, from verb/image, to radioactive and chemical.

8. The Babel tour: religions, ideologies, countries and busineses/competing to controll societies and resources. Grours

are going towards a garbage deposit turning arround the
n, inahabited by millions and millions of people attacking
d robing each other permanently, forever.. hell, degrada-
on.

— • —

106

● THE PAST IS DATA.

THE FUTURE, POSSIBILITIES.
WE ONLY HAVE THE PRESENT.

 Eternaly.

THE FUTURE IS DONE IN THE PRESENT,
WITH PROYECTS; in all levels, from
individual to global level.

A CULTURE IS A DIALOGUE.

WE ENTER THAT DIALOGUE WITH A PROJECT.

● PROJECT:

 1. UNITE OURSELVES WITH GOD,
 TECHNICALY, (with yoga).

 Globaly, tought in gym
 classes, Unesco program.
 And through satelite TV.

 2. INTERDICIPLINARY GROUPS,
 INTERRELATED, IN CHARGE.

 A technical administration
 of the planet and all it
 contains, taking into account
 both coordenates: space/time,
 (endelss and perfect reci-
 cling).
 Normal salaries, its mem-
 bers chosen by teir own scho-
 ols: agriculture, medecine,
 ecology, education, yoga, etc.
 for each zone.

 Everything in vew.
 A service.

Ending the Babel tour of Reli-
gions, countries, ideologies, political
parties, leaders politicians.

ORDER.

- INDIVIDUALY:
 1. VOCATION- start it at 0, AT ANY age.
 2. GROUND- with savings.
 3. YOGA- become one with God, technicaly.
 4. TAKE EVERYTHING IN CHARGE, AND SOLVE IT. (With paper and pencil, first, and act accordingly.)
 5. SERVE, each one on his/her field and level.

Adults, in charge. Objective. Awoke.

- GOALS:

 1. Endless and perfect recicling of the planet and all it contains. Technicaly.

 2. live in happines, and harmony everybody, all over, in the present,

 (technicaly).

- THE VOYAGE IN THE FOURTH DIMENTION, (time), (endelss recicling), IS CALLED:

 EVOLUTION
 or
 DEGRADATION.

And is decided in two ways:

 TAKING THINGS IN OUR
 CHARGE AND SOLVING THEM,
 or,
 ABBANDONING.

108

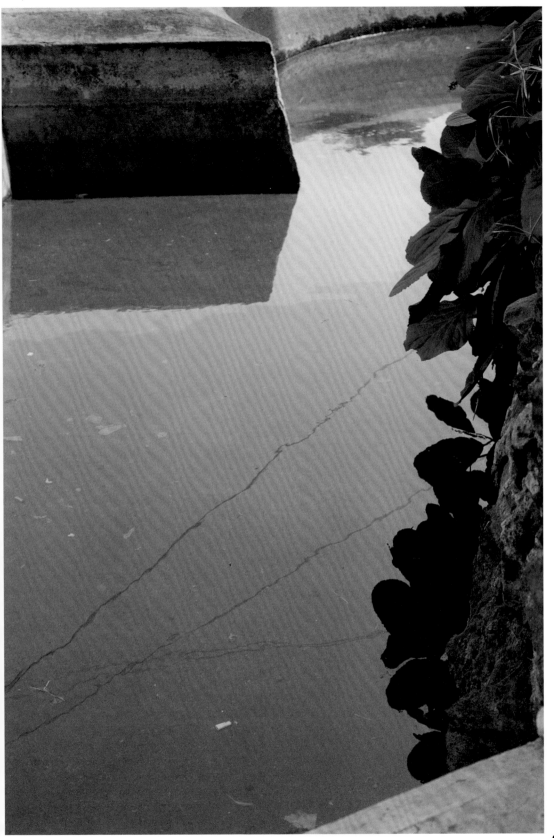

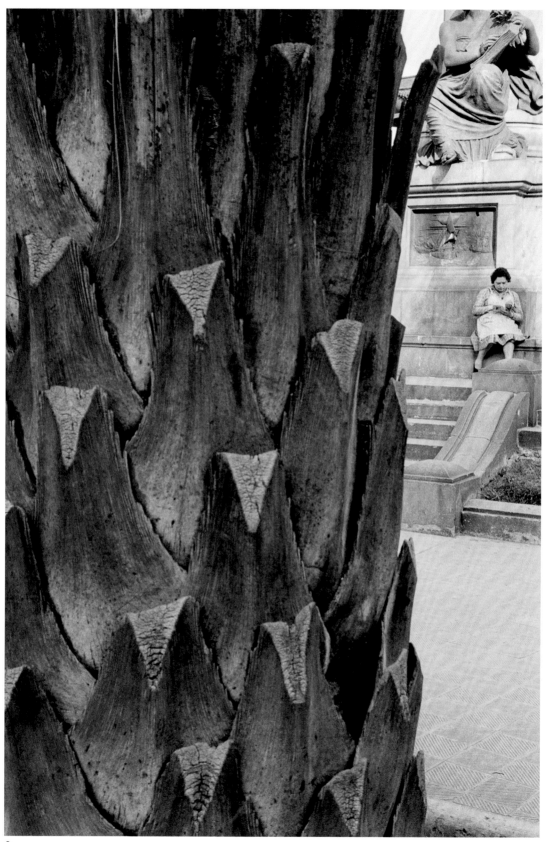

111

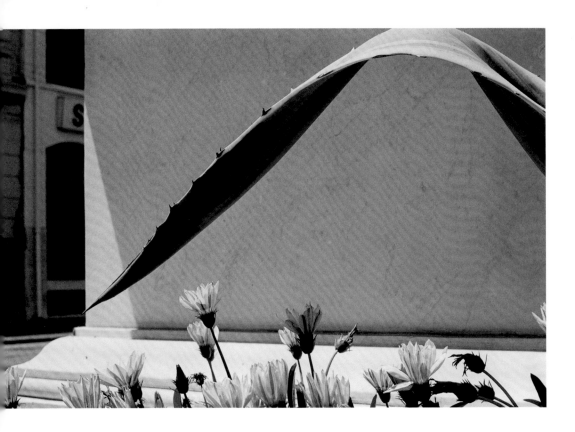

TRANQUILITY.

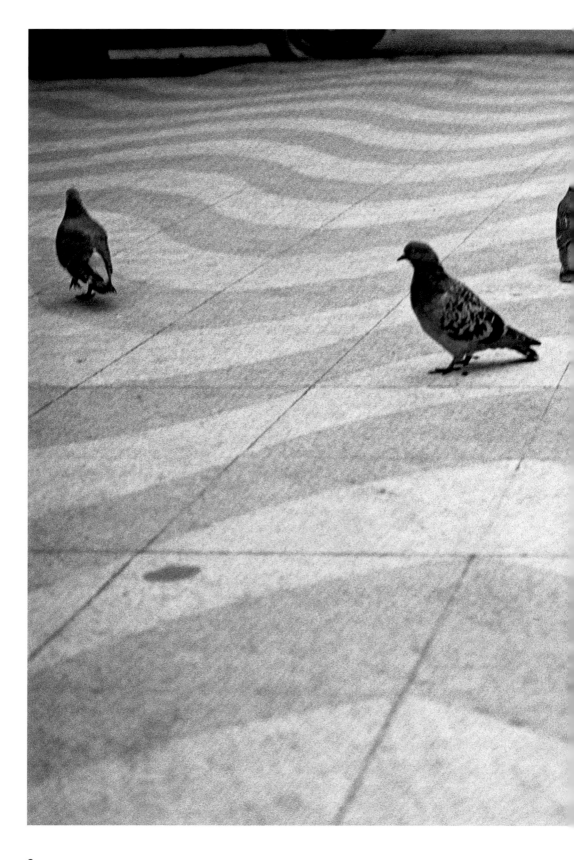

113

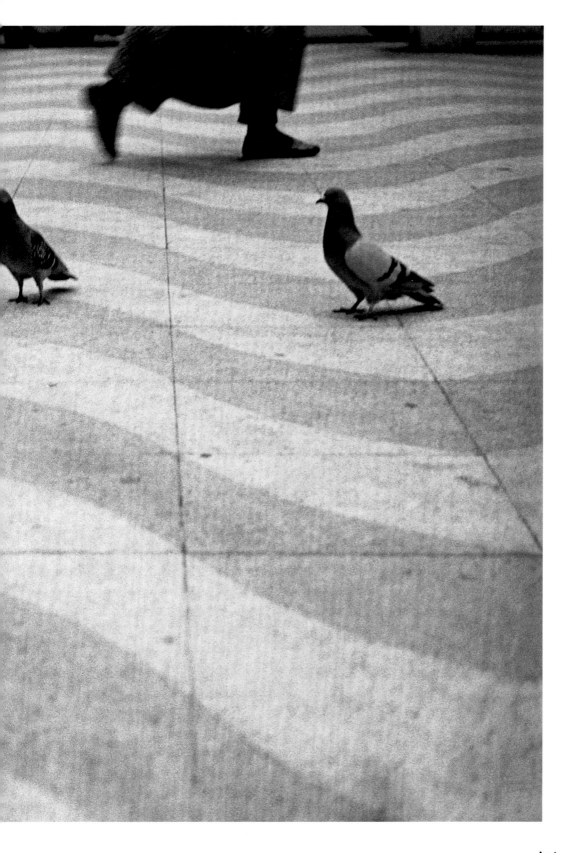

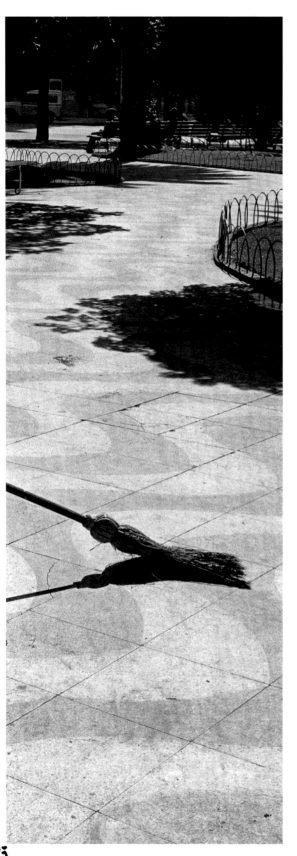

NO TIME,
¡THE PRESENT!

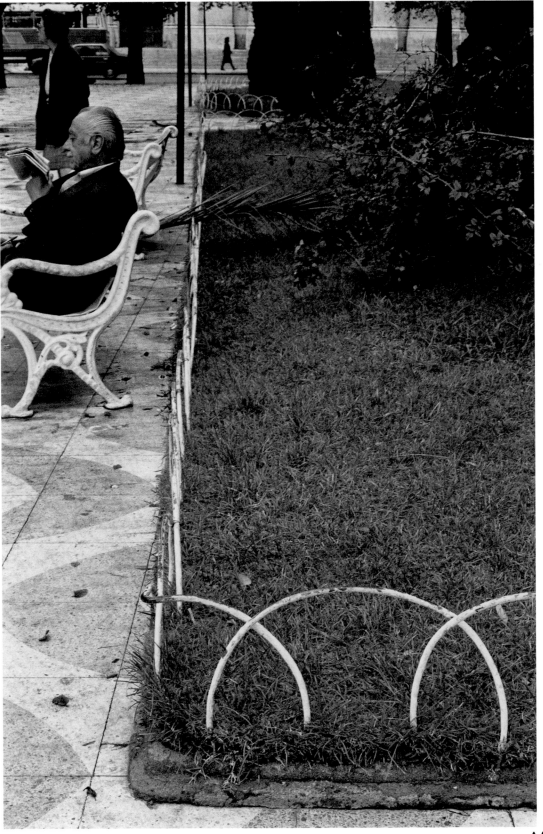

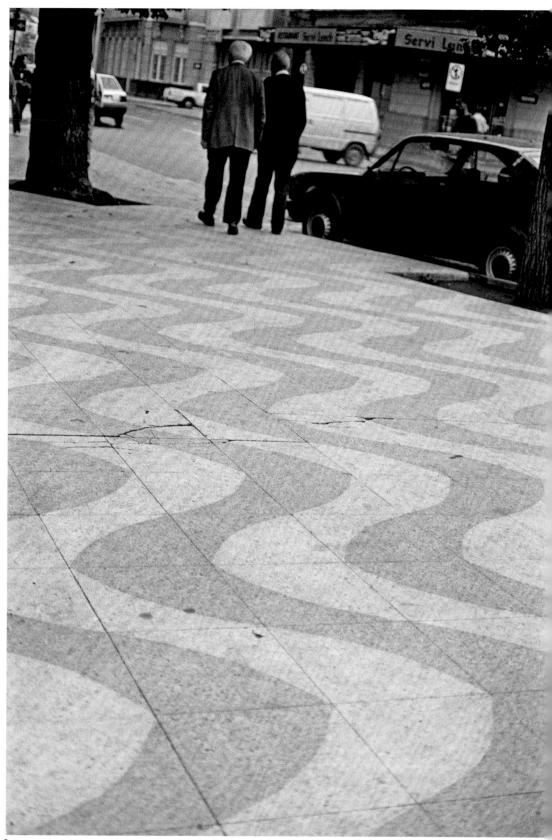

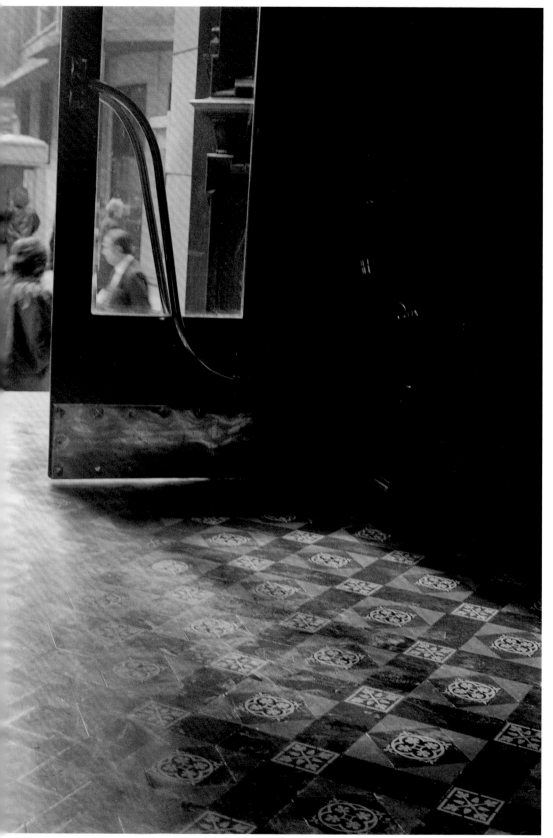

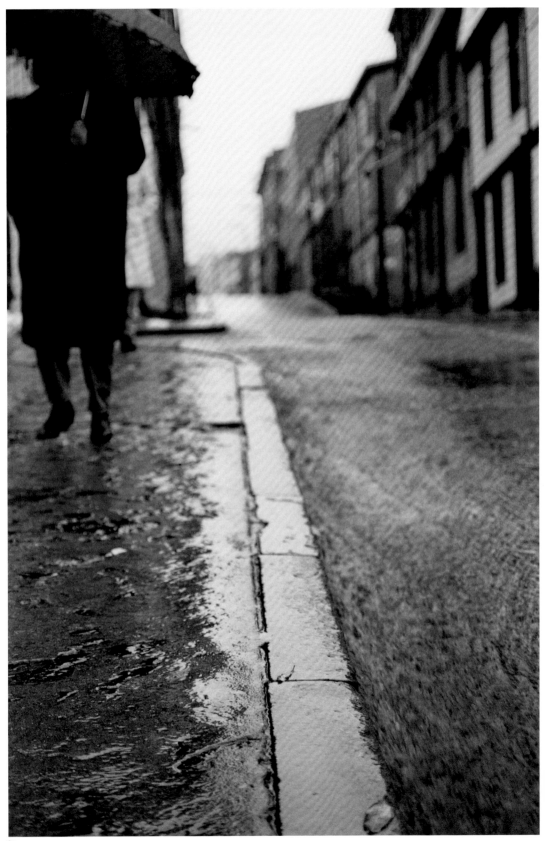

119

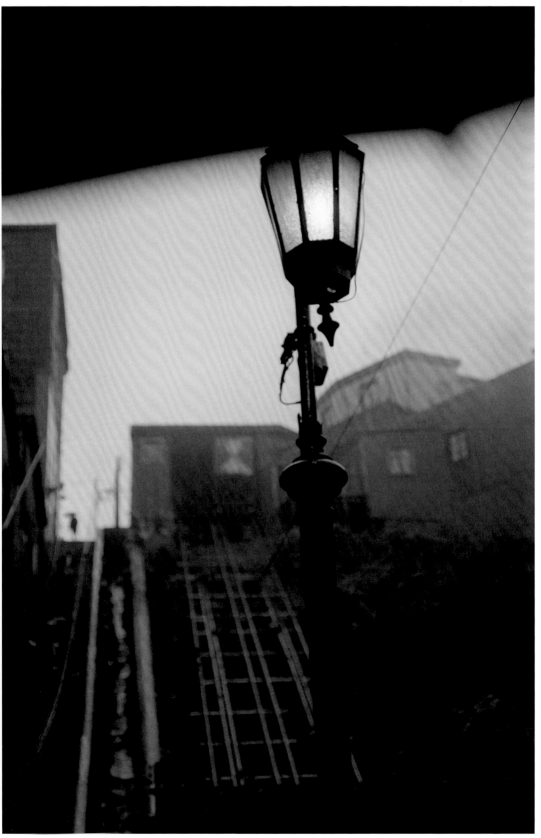

120

126

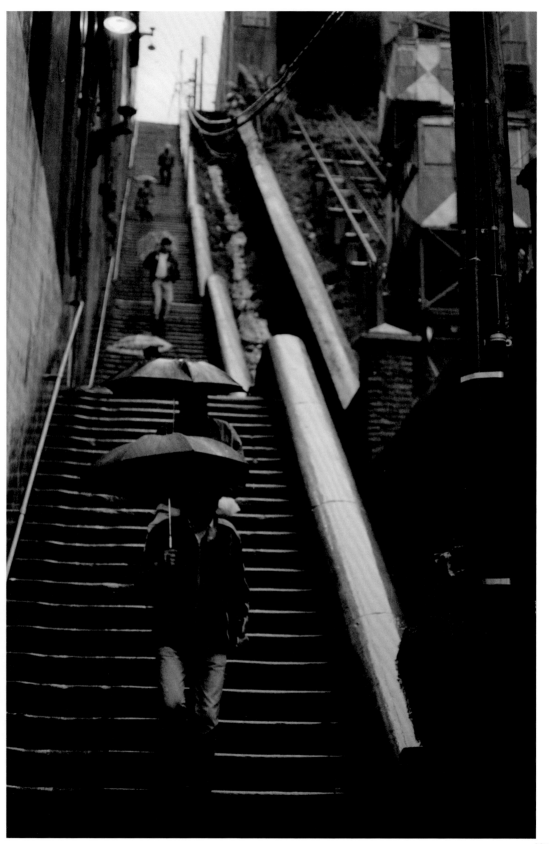

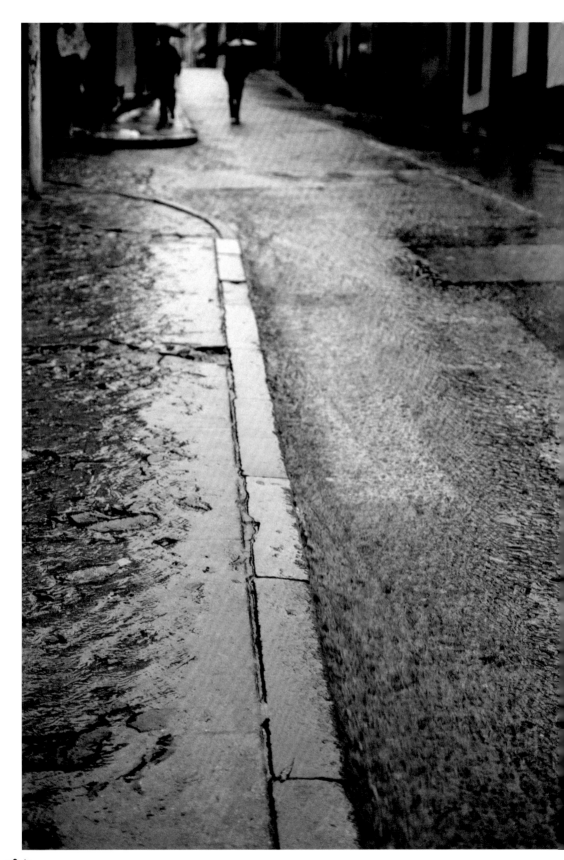

124

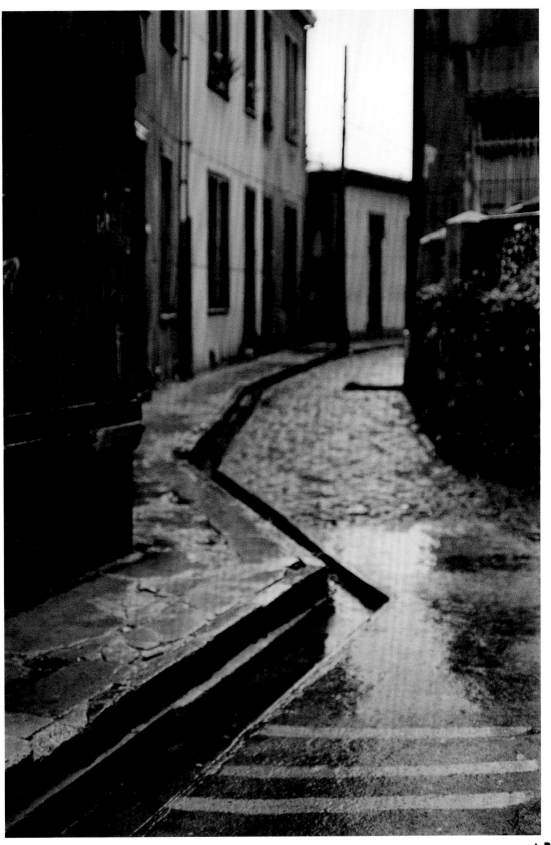

NO HURRY.

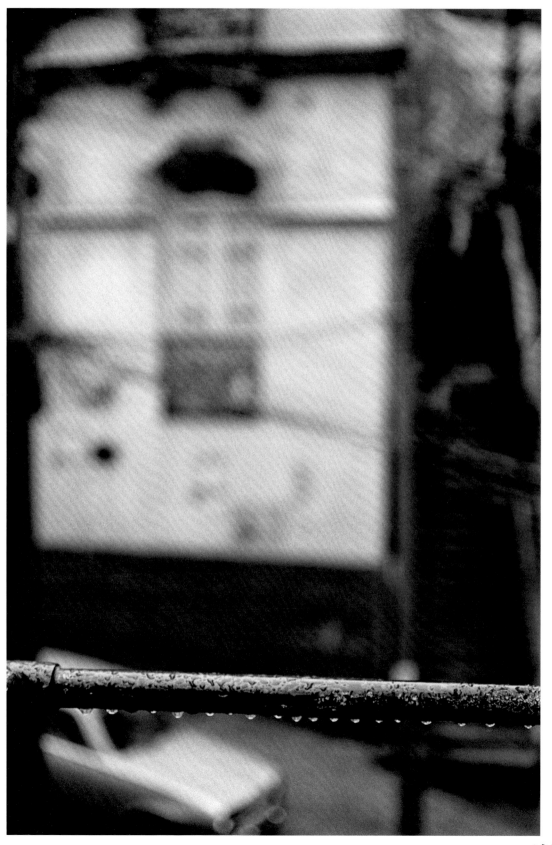

127

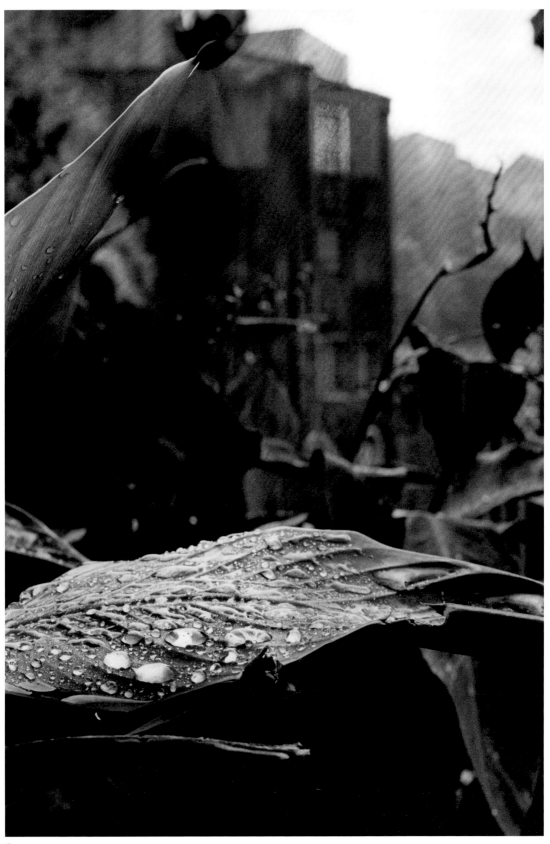

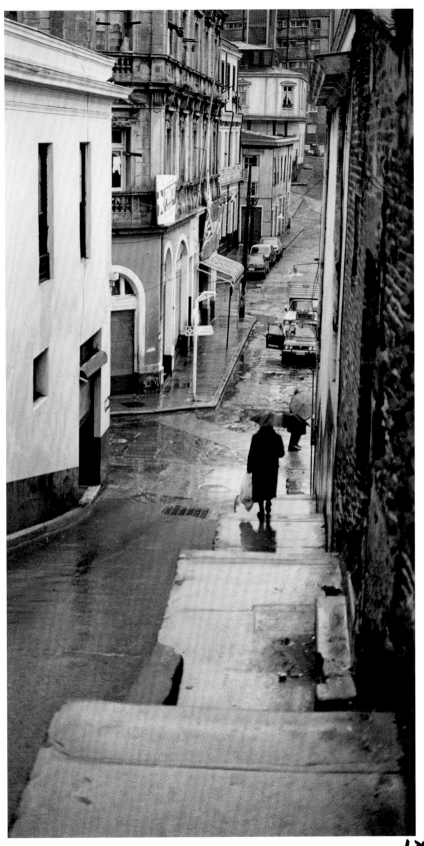

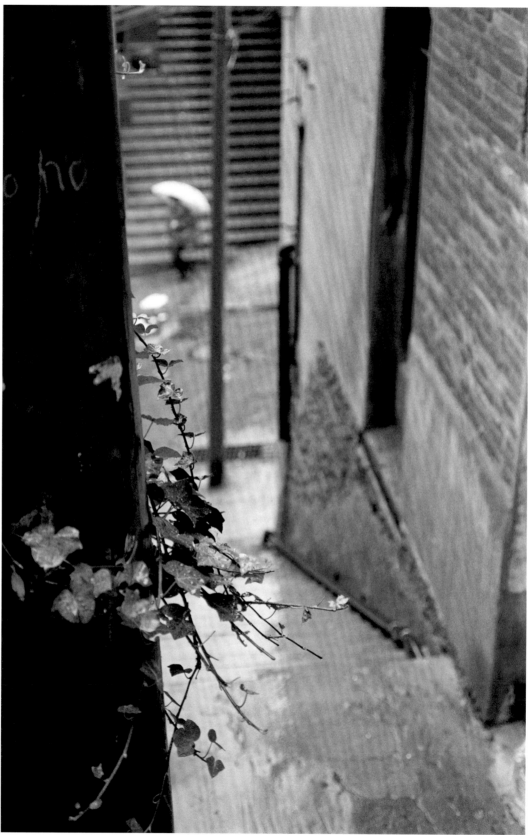

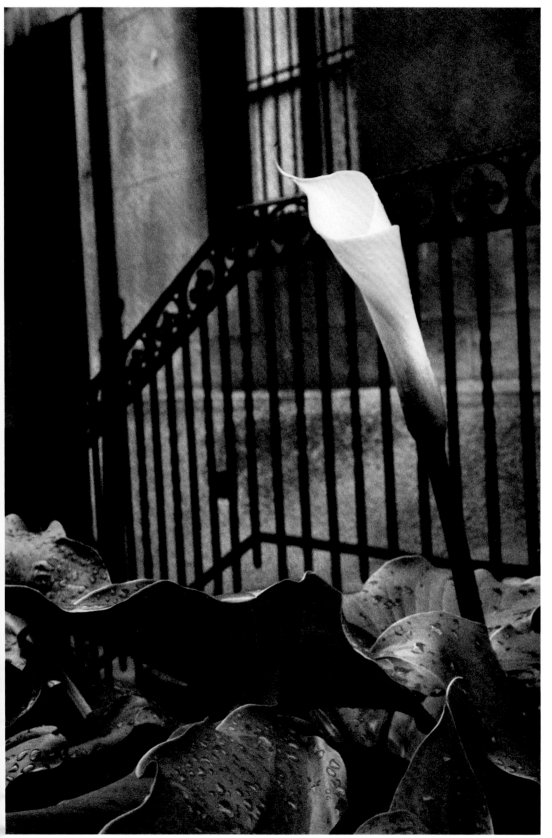

131

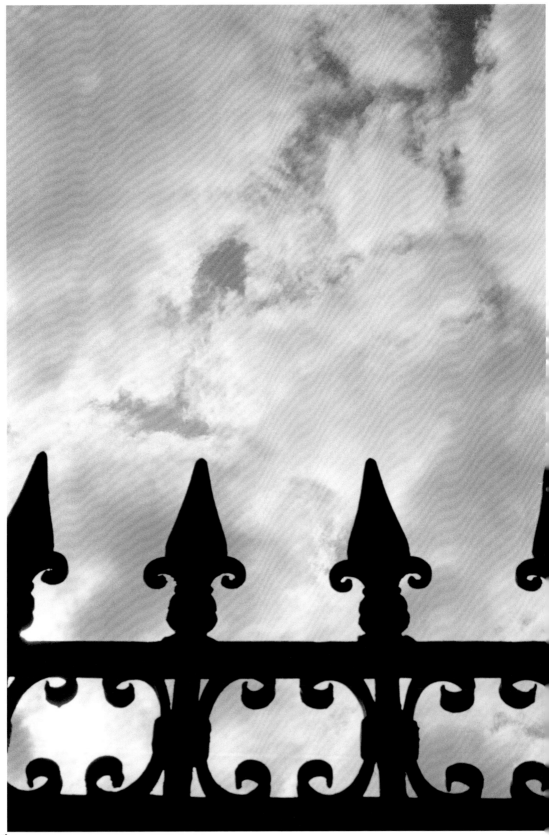

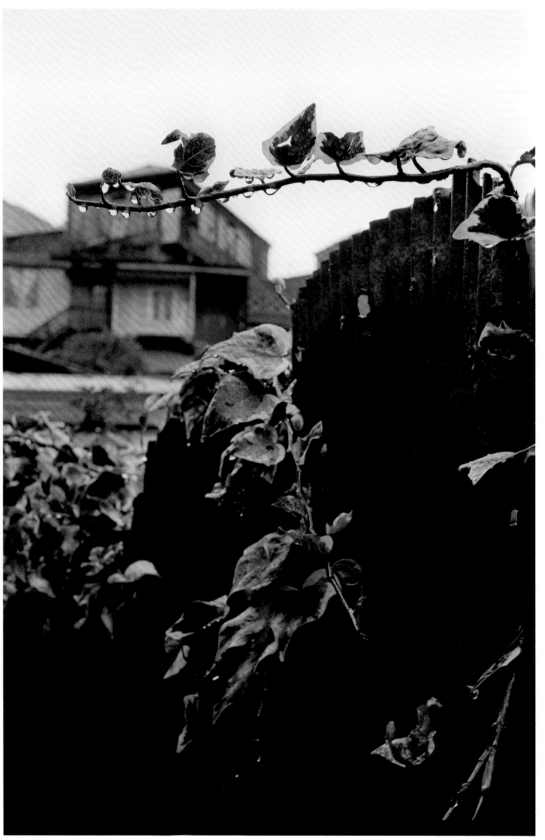

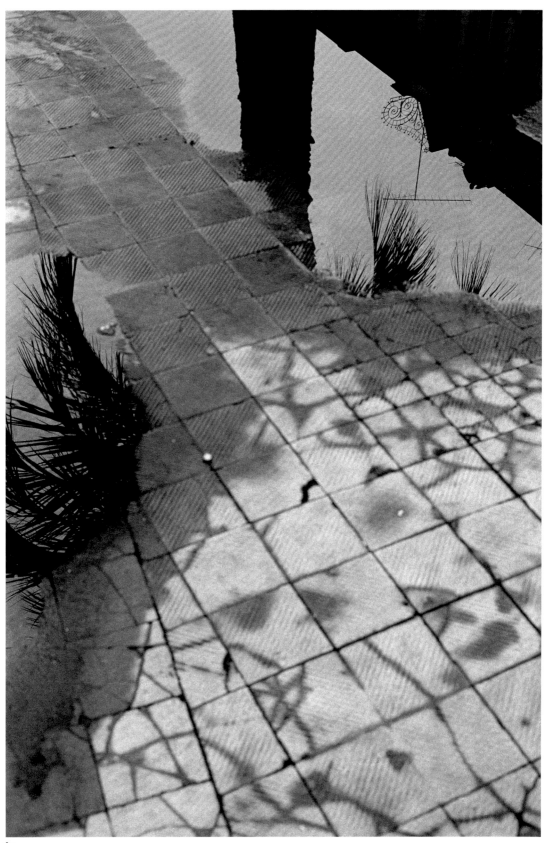

134

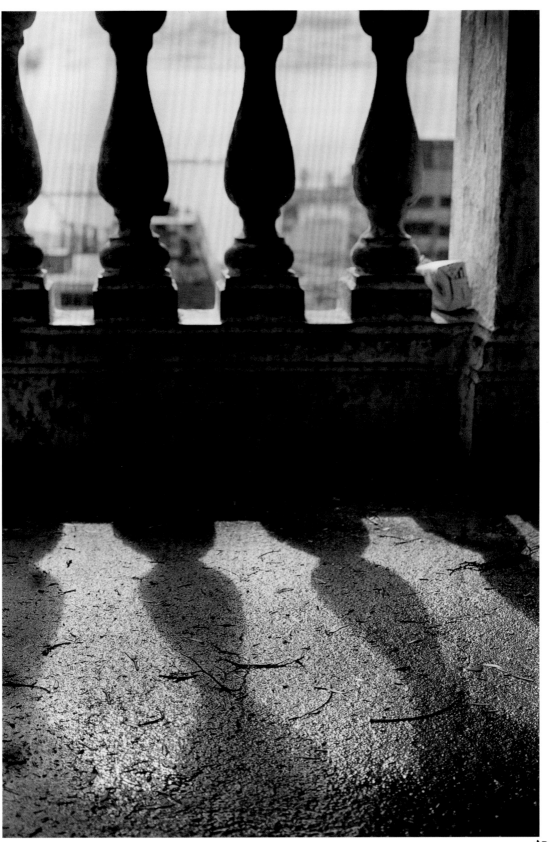

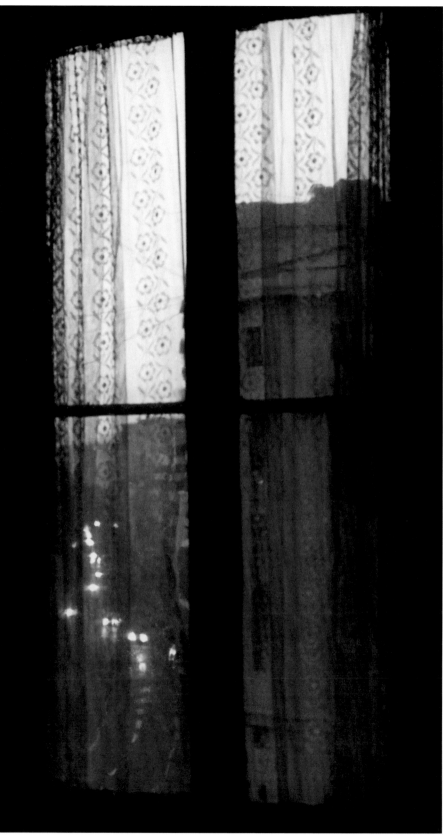

136

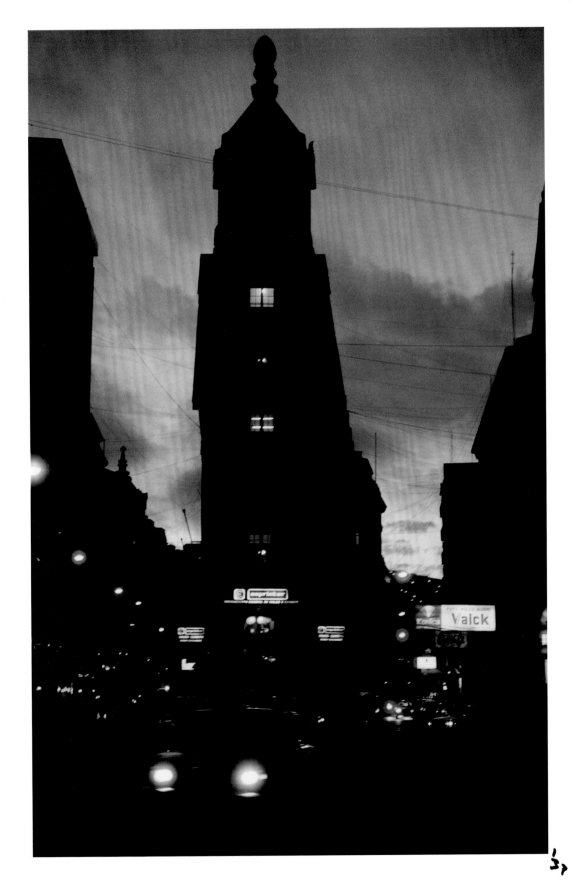

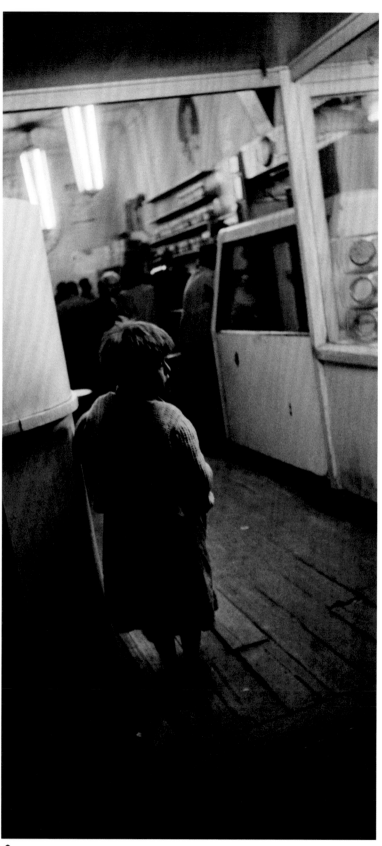

13.8

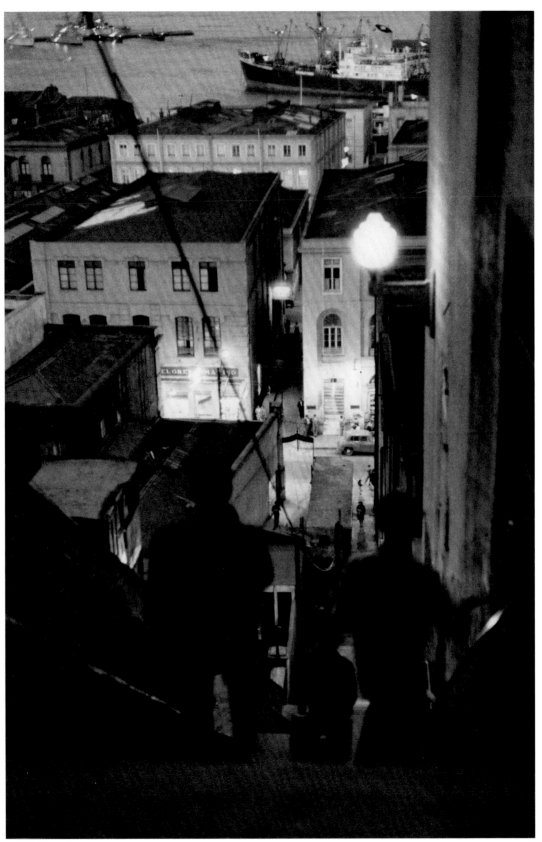

139

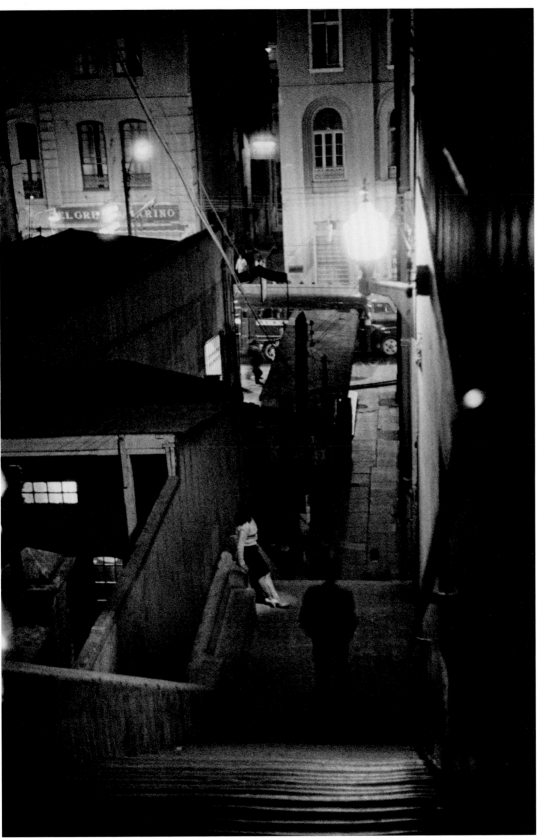

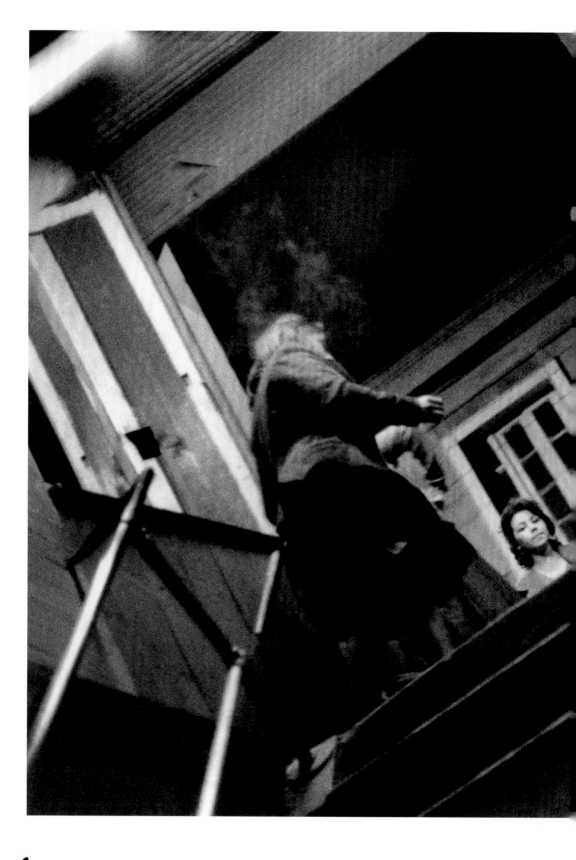

143

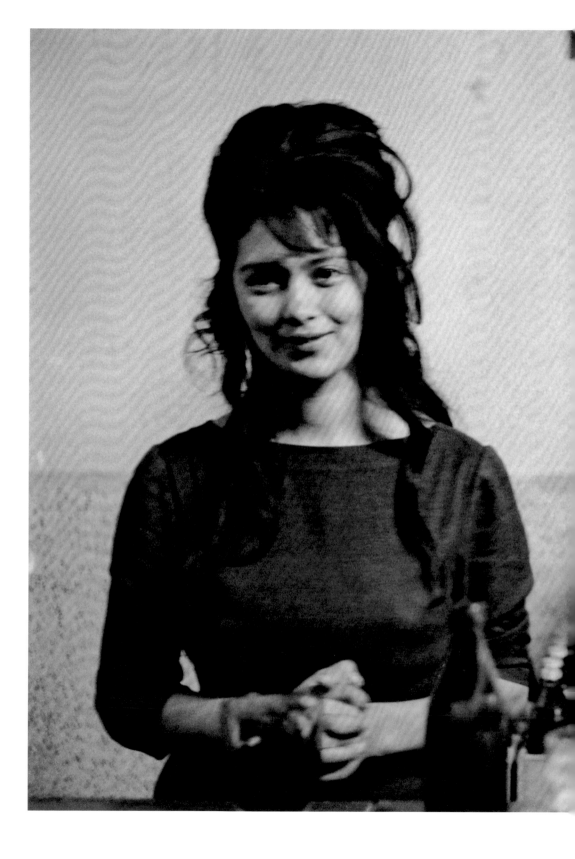

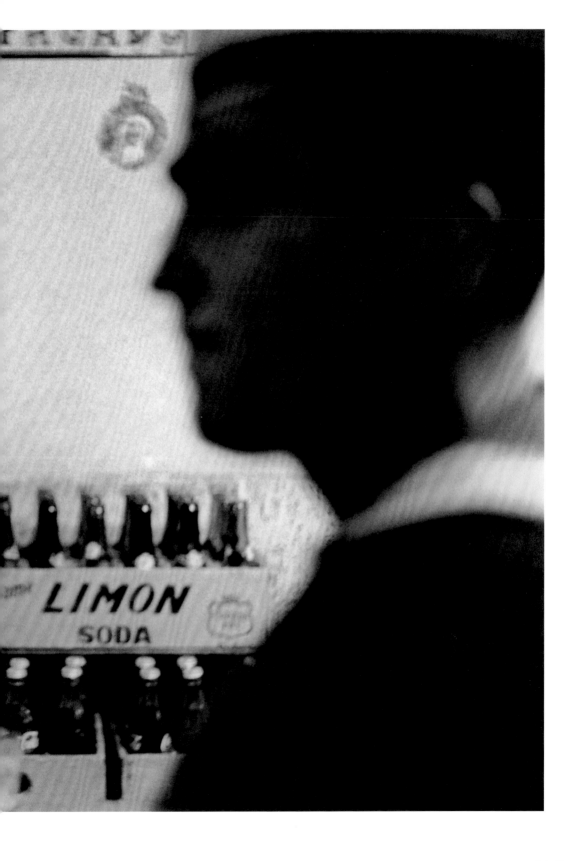

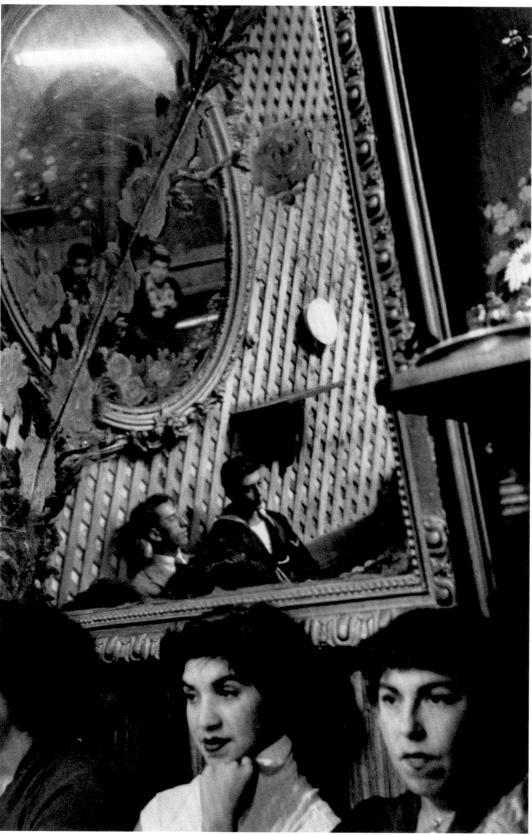

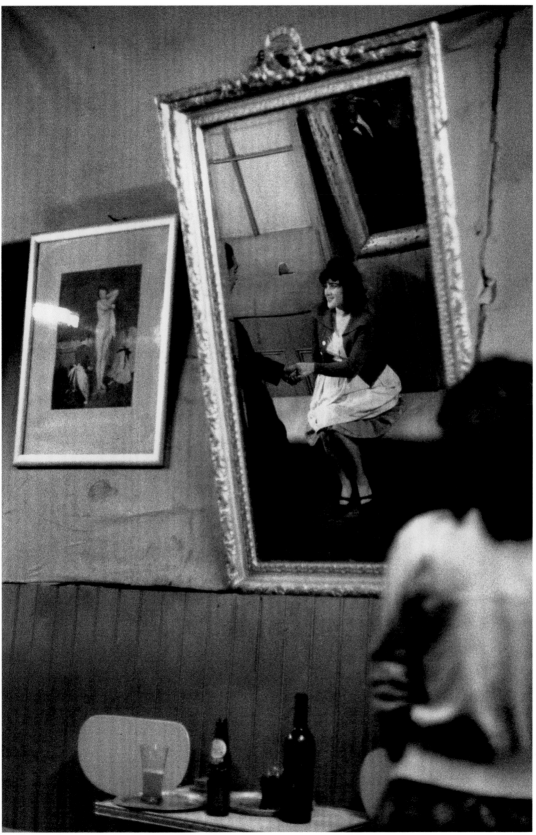

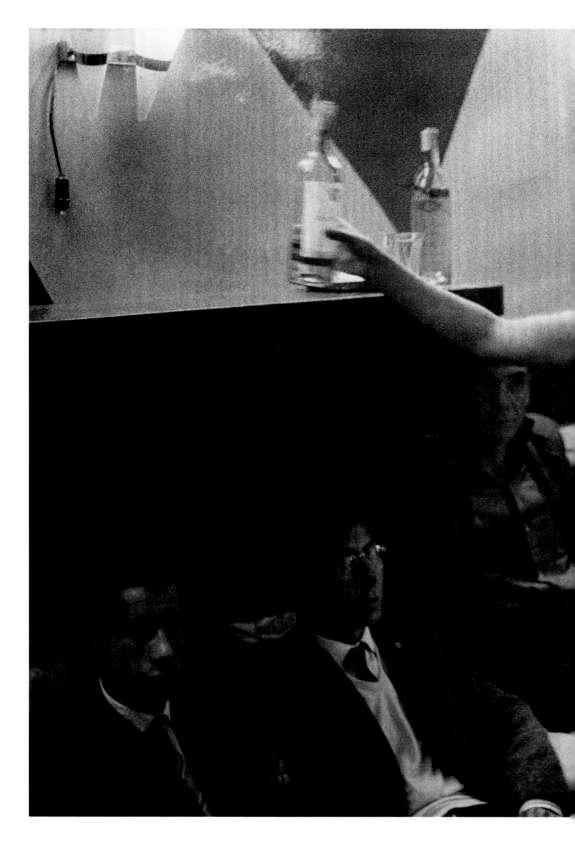

148

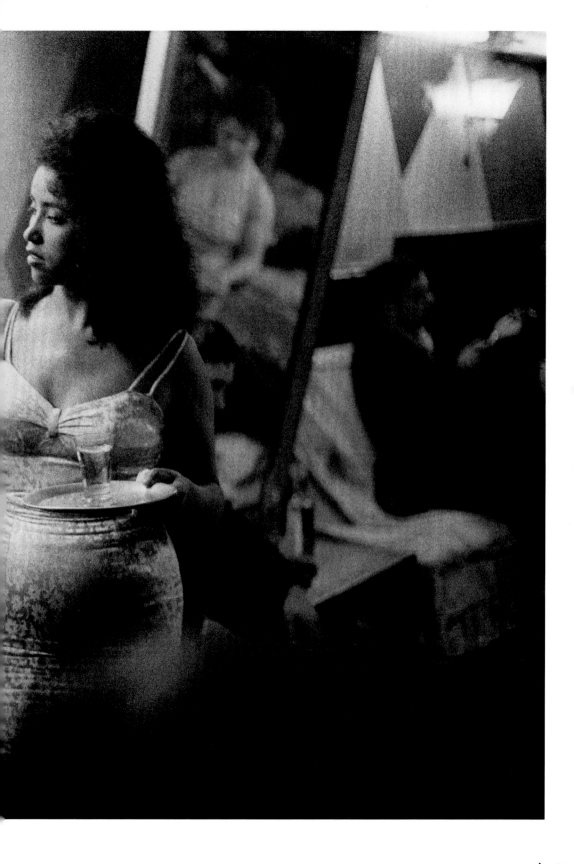

149

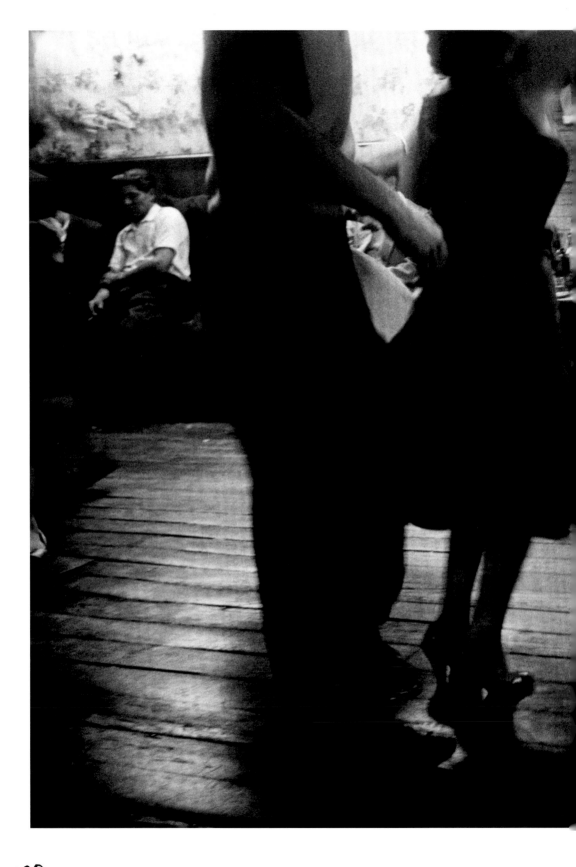

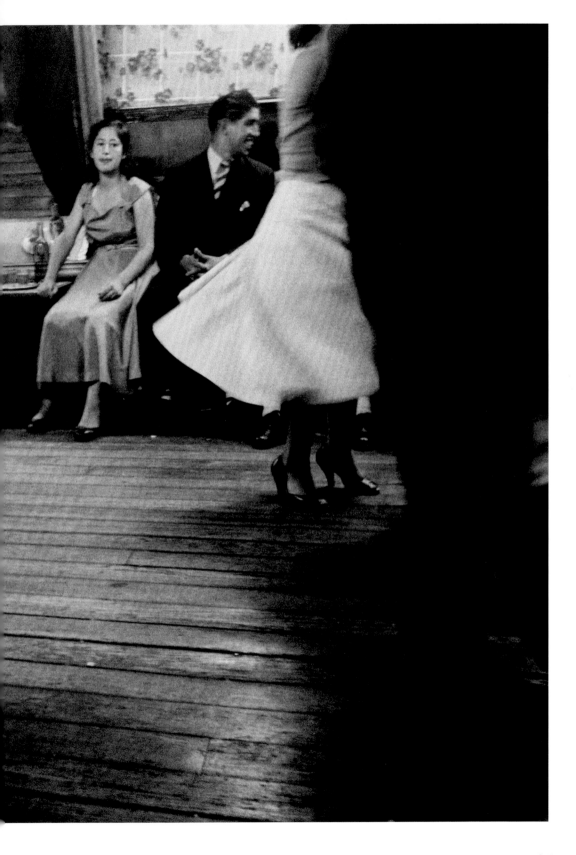

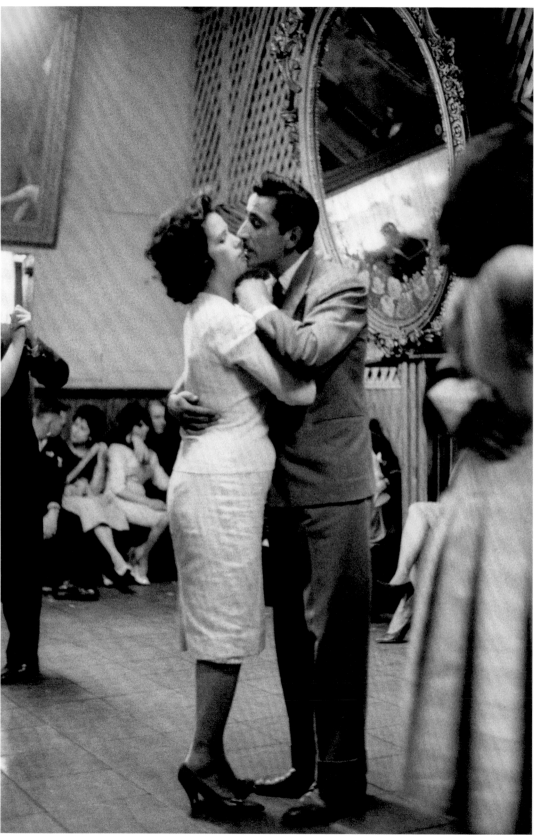

156

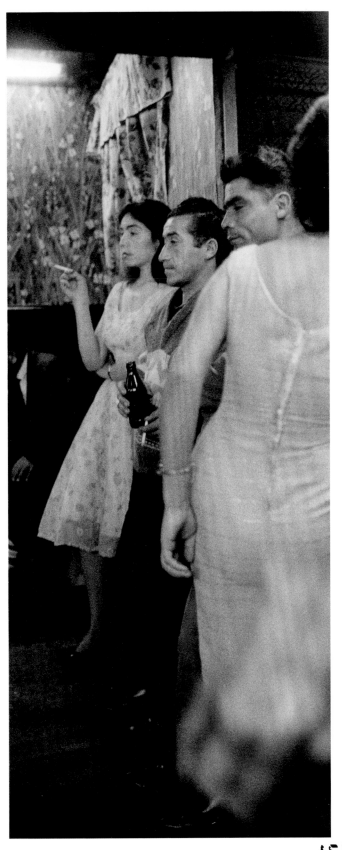

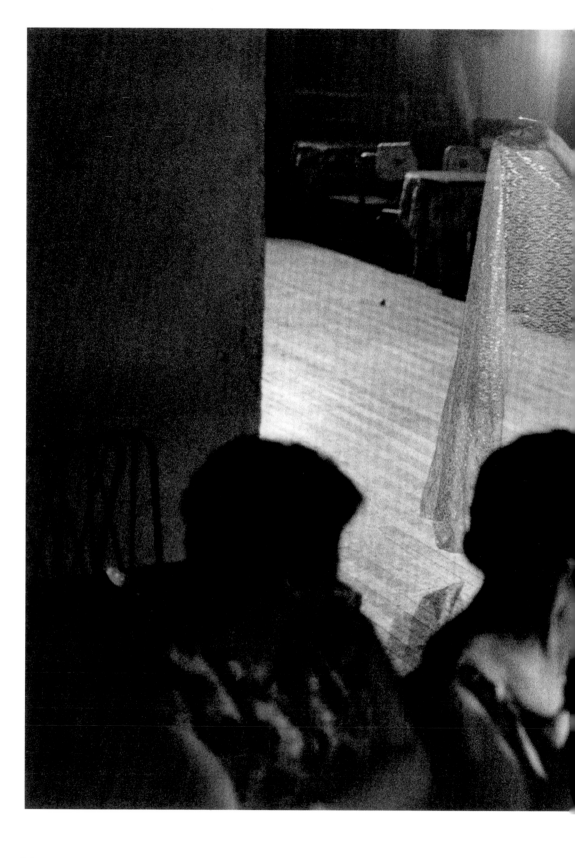

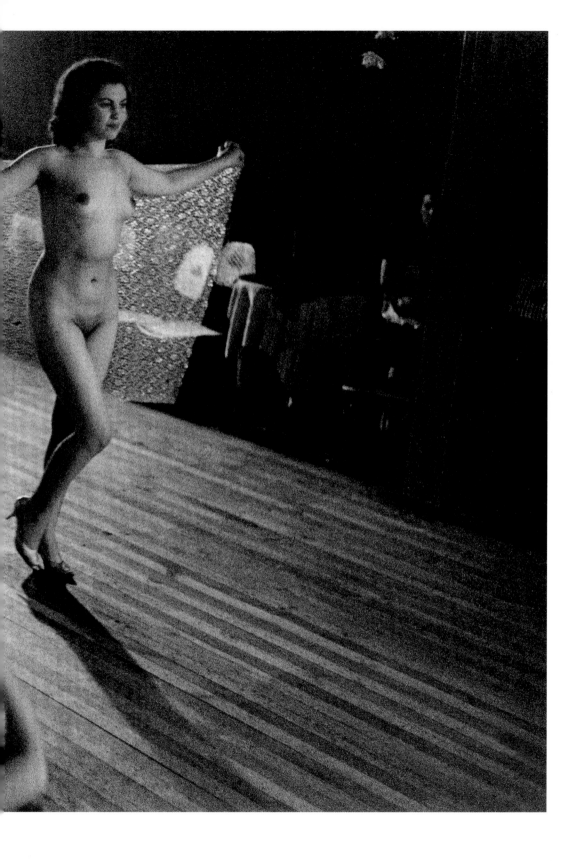

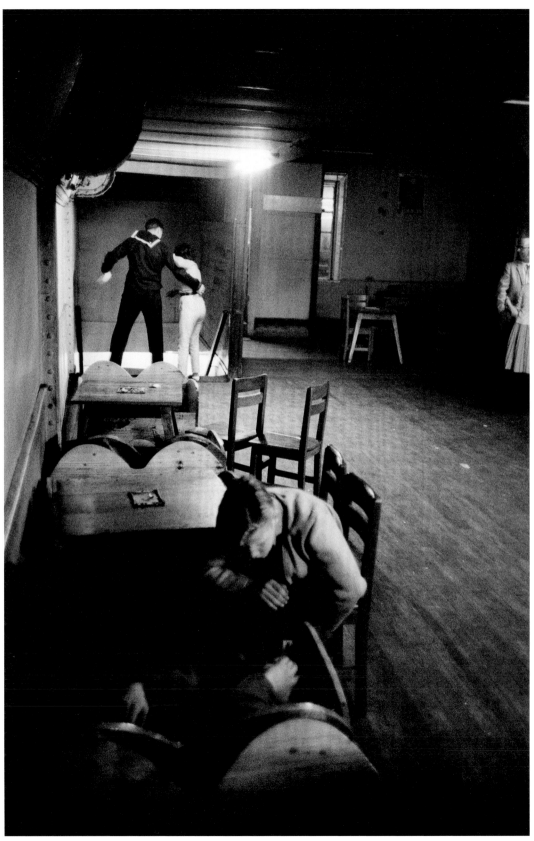

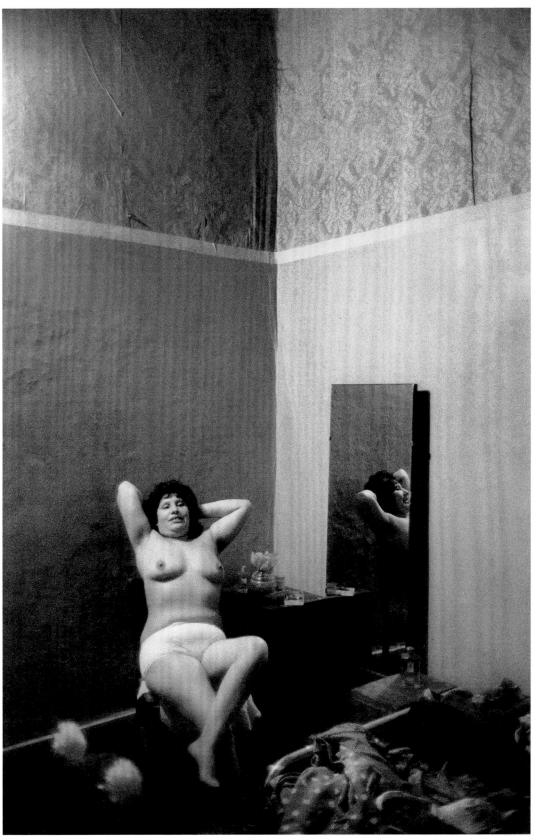

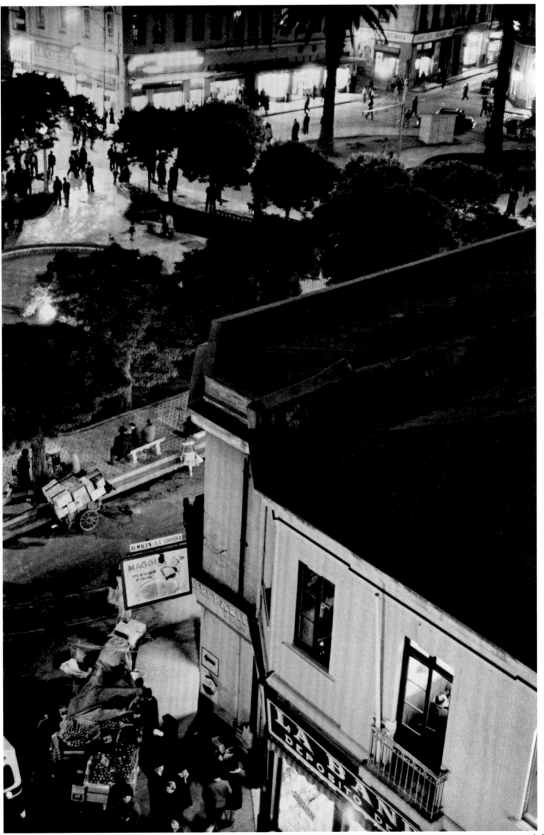

159

The act of
poetry,

(the act of
photography).

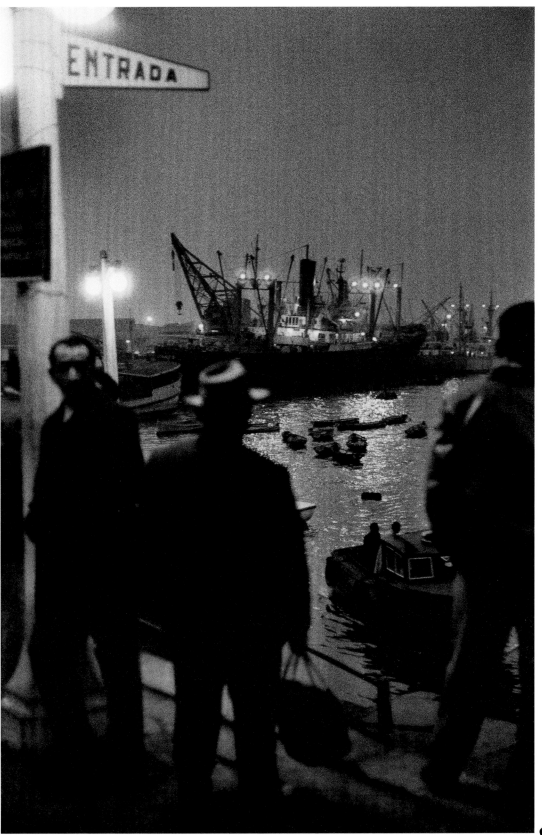

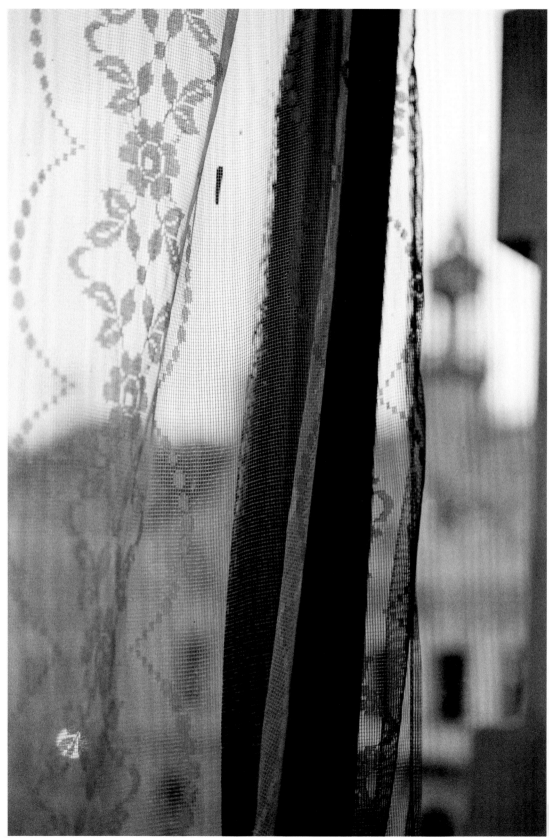

162

"THE PRESENT/INSTANT is THE GOAL.

NOT THE WAY, BUT THE GOAL."

- THIS IS <u>THE KINGDOM</u> OFFERED IN
 ETERNITY,
 ALL THERE IS, the eternal now, AND IT IS
 (AND WE ARE DESTROYING IT).

(Entering
the
present
with
a
craft .)

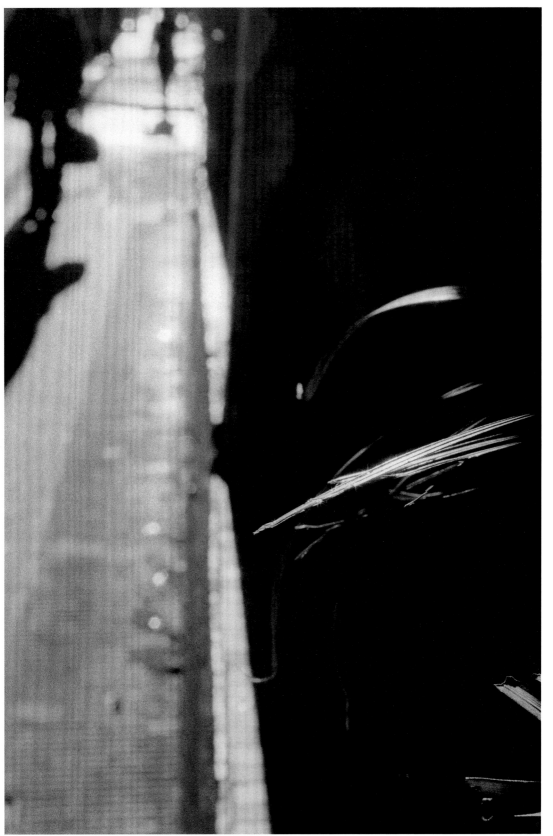

CON-
CIOUS-
NESS.

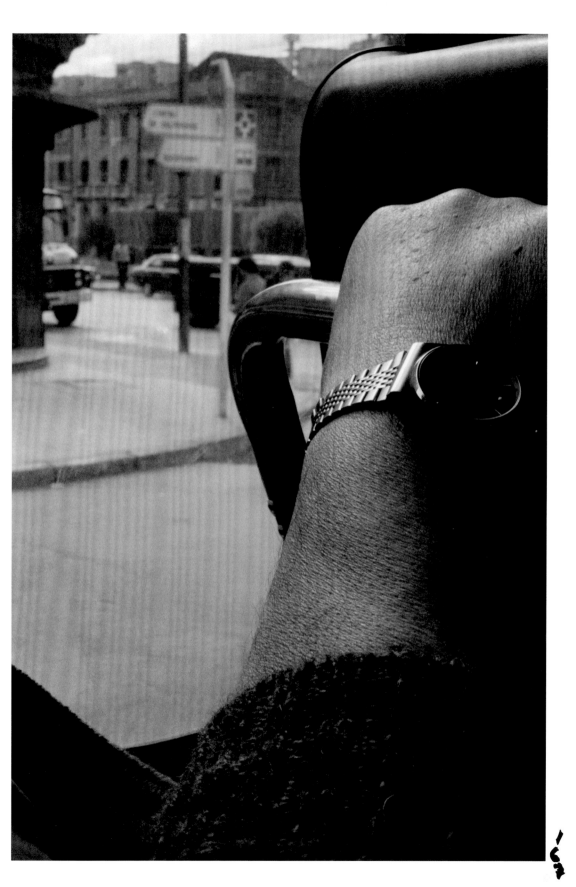

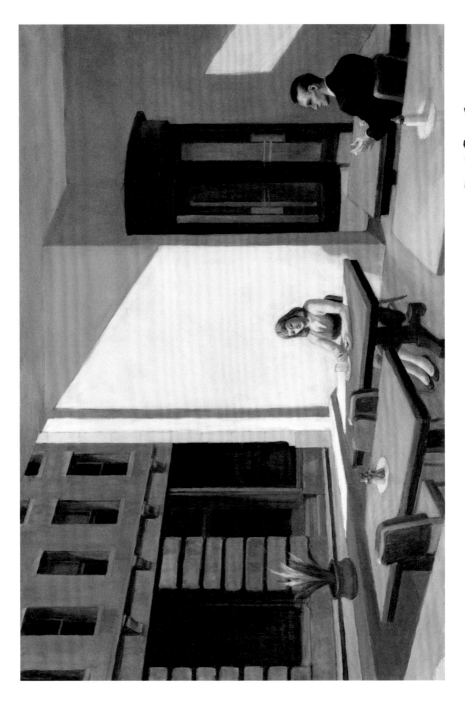

HOPPER.

168

"ART IS AN APPROACH
TO THE STATE OF SATORI."

169

● SATORI, is to be awoke in the present, and is simply done:

 1. Put your attention in the KATH point, (4 cmts. under the navel).

 2. Conect the kath to the ground, (planet).

 3. Stop associations with a mantram, (ex. NO SE NADA, NO SE NADA.. for hours!, days!, forever!).

 4. Solving all situations with paper and pencil, day after day, situation after situation, (from personal to planetary level), and act accordingly.

LIVE IN THE DAY, not in time.

NO OPINIONS - NO DESIRES = SATORI.

Is done technicaly, with yoga.

— . —

- THE COSMIC SCALE:
 universe
 galaxi
 star
 life – sun
 planet – earth
 satelite – moon

 DO, RE, MI..
 THE SCALE OF LIFE:
 man
 animal
 birds
 reptiles
 fishes
 insect
 vegetable
 cell

 DO RE MI..
LIFE

 KATH–
(4 cnts. under
the navel, grounded).
In THE SEPTENARY LAW, scales.

In the UNIVERSE, (not two verses).

— • —

- LIFE is an intermediary note, betwe-
 en two notes in the Cosmic Scale,
 that develops itslef into a scale.

— • —

STAR

INTELLECT.
EMOTION
MOTRICITY

PLANET

THE KINGDOM.

1. UNITE OURSEL-
VES TO GOD WITH
YOGA.
(Not divide with
religions).

2. INDIVIDUAL LIFE
WELL SOLVED.
(House with vegetable gar-
den and fruit trees.- Vocation.)

3. OBJECTIVE CONDUCTION OF SOCIETY.
(Interdiciplinary groups, coordinated
among them, in charge. No more verbal
divitions, (countries, ideologies), or
partial advanta —.—ges.

4. LIMITED HUMAN POPULATION.
(With one child per mother, bring population
down, untill everyone has house with vegetable
garden and fruit trees. In planetary agreement.)

5. SIMPLIFY OURSELVES. CONSTRUCT AND PRODUCE ONLY THE
INEVITABLE; WITH MATERIALS THAT RECICLE WELL.
(Dismount all atomic devices, and never produce them again.
Transform busineses into services).
Monks are a reference OF the real needs we have.

6. AGRICULTURE DONE WITH WISDOM - NATURAL ENERGY.

7. RECUPERATE; COMPLETELY! GEOLOGY AND ECOLOGY.
The planet a garden, a convent, turning arround it's star.

AN ORDER WITHOUT CONTRADIC-
TIONS IN THE PIRAMID OF
REALITY.

AS TIME DOES NOT EXISTE, TO LIVE IN HARMONY, IN THE PRESENT, IS THE GOAL.

GAME.

THE GAME OF TAKING THINGS IN
OUR CHARGE, AND SOLVING THEM.

1. Write down the present
 situation, in all levels,
 from personal to planetary.

 We call that NOW.

2. Write down what would
 be the ideal, the best
 solutions, for all le-
 vels, (considering the
 two coordenates: space/
 time. Endless recicling).

 We call this GOALS.

3. Write down the steps to
 go from 1 to 2.

 We call that PROGRAMS.

4. Give the steps.

 We call that WORK.

— • —

THE END.

TEXT FOR THE PLANETARY KINDERGARTEN

OVALLE 1993 - SEPTEMBER.

All photographs were taken in Valparaíso between 1952 and 1992.
1952: page 4; 1953: page 35; 1954: pages 62, 70; 1957: pages 34, 146,
150-151; 1963: pages 11, 13, 18, 22, 23-24, 30, 31, 40, 45, 46, 48, 53,
59-60, 65-66, 67, 80, 92, 95, 96, 100, 111, 139, 141, 142-143, 144-
145, 147, 148-149, 152, 153, 154-155, 156, 157, 159, 161; 1978: pages 9,
25, 43, 55, 69, 71, 75-76, 85, 112, 134; 1979: page 79; 1980: pages 68,
73, 77-78, 81-82, 97-98, 115, 121, 131, 165; 1991: pages 50, 56, 57, 110;
1992: pages 6, 7-8, 14, 37, 38, 41-42, 44, 52, 63, 64, 72, 74, 83, 84, 86,
87, 88, 89, 90, 93, 94, 101-102, 105, 113-114, 116, 117, 118, 119, 120,
123, 124, 125, 126, 127, 128, 129, 130, 132, 133, 135, 137, 138, 162, 167;
date unknown: pages 36, 47, 51, 54, 58, 136, 166.

Planet Valparaíso

Agnès Sire

'If we walk up and down all of Valparaíso's stairs,
we will have made a trip around the world.'[1]
Pablo Neruda

In June 1991, Éditions Hazan published the book *Valparaíso* by Sergio
Larrain, with a text by Pablo Neruda. It had a modest print run and sold
out very quickly. The story of this book is worth retelling in detail.

Charmed and intrigued by this talented Chilean photographer who
had vanished from the scene, the employee of Magnum I was at the time
had begun a regular correspondence with Larrain five years earlier, which
was brusquely cut short only by his death in 2012. I was beginning to get
a better sense of this shadowy figure, born in Santiago in 1931, a man who
wanted to live as a hermit and save the planet. He wanted to get away from
the press that he had once supplied with photographs, for the few years
in which he accepted commissions from Magnum, aware of the essential
emptiness of reportage as an endeavour, yet still carrying out this work with
panache. A letter to his mentor Henri Cartier-Bresson from 1962, a time
when he had only been collaborating with Magnum for three years, shows
the early signs of his growing insight: 'there is the problem of markets... of
getting published... of earning money.'[2]

Here we see this rebellious spirit, unable to accept mediocrity, antic-
ipating the crisis in photojournalism at its peak and the debates about
auteur photography that occurred several years later (Henri Cartier-Bresson
leaving Magnum in 1969, the founding of the agency Viva in 1972, etc.). We
also see a tormented spirit who preferred the calm of introspection to the

media spotlight. While his eye excelled at capturing fragments of reality in his viewfinder, he also had no fear of what lies beyond the frame, what is yet to come, bold diagonals, blur, bright sunlight or darkness. His images are not closed, the people in them are often moving away, elusive and fleeting, as resistant to being fenced in as Larrain himself.

Born into an educated bourgeois family in Santiago, Sergio Larrain was the fourth of five children. During the short period he spent studying forestry at the University of California, Berkeley, he saw a Leica camera in a shop window and was so eager to buy it that he traded in his flute and spent many hours washing dishes in a restaurant. 'At that time, in 1949, I bought my first camera, never imagining that photography would become my profession,'[3] he said. 'Then back to Chile, where I did go to live alone in a peasants' adobe house I rented for a year. I wanted to be alone, and find myself (now 21)... I spent the year barefooted, doing yoga – I did not know what it was – and reading all there was on that subject... The year's loneliness cleared my mind, and at the end I had satori (without knowing it). I was back [at] one with the universe, like a child, being so tranquil and undisturbed. During that period, I had my lab and went from time to time to Valparaíso to take photos, and being so clean, miracles started to happen and my photography became magic.'[4]

The street children of Santiago would become the subject of the first substantial piece of work by this young photographer who was so resistant to the idea of fitting in; they were like a mirror of his own personality and an expression of his longing for social change. A five-minute short film, *Los abandonados* (1965), the only film that Larrain ever made, is also a perfect demonstration of his familiarity and empathy with this vagabond state. Simultaneously a protest against the invisibility of these abandoned children and a homage to their freedom, the film feels like a Chilean counterpart to *In the Street* (1948), filmed in Harlem by Helen Levitt.

After his work with the street children, Valparaíso virtually became home soil to Larrain from an early age. Every stone, every stairway, every sailor, every shadow and every bar became an indispensable piece of vocabulary in the huge poem that he wanted to write. His best-known image, showing two little girls walking down the steps of the Pasaje Bavestrello, dates from 1952, when he was just twenty years old: 'I started in Valparaíso, roaming the hills night and day. The little girls walking down a staircase was the first magic photo that presented itself... Things like that only happen in Valparaíso.'[5] This was followed by his time with Magnum (which he joined in 1959), which was clearly not a favourable environment for 'magic', although he freely admits that it was a crucial period for his output. After three intense years in Europe, he returned to Chile in 1962, now married

Portrait of Pablo Neruda by Sergio Larrain, Isla Negra, Chile, 1963.

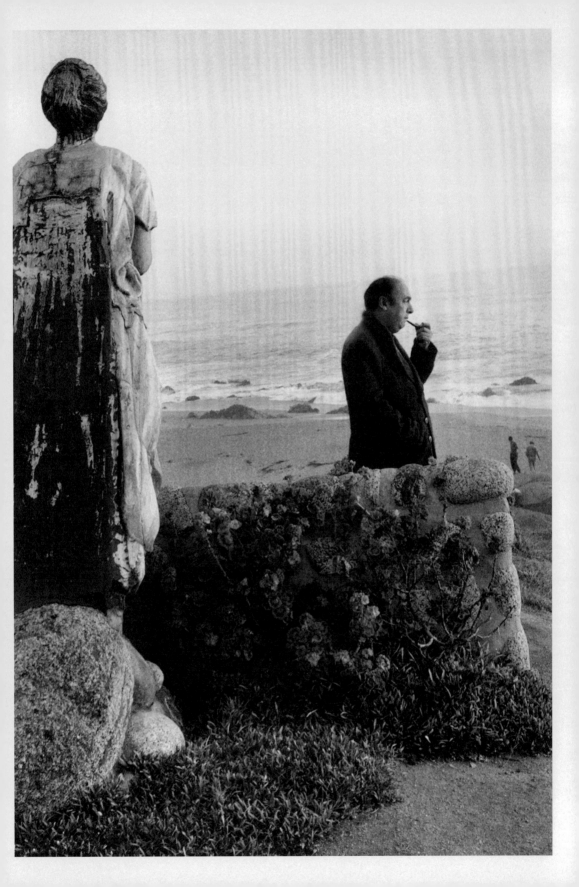

Photographs of the exhibition 'Valparaíso' at the Maison Pablo Neruda, Arles, France, July 1991.

and father to a little girl. After an exhibition in Santiago, he published *El rectángulo en la mano* (*The Rectangle in the Hand*),[6] a small book that he designed himself, comprising seventeen photographs and some brief reflections on the medium: 'In photography, the subject is derived through geometry.'[7] In this respect, he was in firm agreement with his friend and role model Cartier-Bresson.

Keen to produce a book on Valparaíso with Pablo Neruda, Larrain spent several months in 1963 working closely with the poet: 'I sometimes spent entire days walking through the streets with him.'[8] With his style now well established, Larrain grew closer to the city than ever, almost becoming one with it. Later, in 1965, he once again confided in Cartier-Bresson, explaining that he ultimately preferred this kind of poetic wandering to the investigative journalism that Magnum wanted: 'I feel that the rushing of journalism – being ready to jump on any story – all the time – destroys my love and my concentration for work.'[9] Neruda, who owned a house overlooking the bay,[10] wrote some beautiful poems, including 'Ode to Valparaíso', about the city where he lived for much of his life, a city that he once called a 'filthy rose'.[11] Nevertheless, the promised book did not materialize. A selection of images published in the Swiss magazine *Du Atlantis* (1966), alongside a text by Neruda, remained the only tangible trace of this shared endeavour until 1991, twenty-five years later. As for the text by the 1971 Nobel laureate, it was not published again until the posthumous appearance of Neruda's *Memoirs* (1974), in which it appears in a slightly extended form.

As part of the Rencontres d'Arles photography festival in July 1991, which was on the theme of Latin America, I curated an exhibition of Sergio Larrain's images of Valparaíso.[12] The idea of trying to get this work published at last, accompanied by Neruda's text, was too good an opportunity to miss. The photographer loved this idea, being less fearful of media coverage of his work at that time than he later became. We made many adjustments to the layout; Larrain's responses, from his hideaway in Tulahuén in northern Chile, took a long time to arrive, but everything worked out well.

Thanks to the support of Xavier Barral, a friend and regular collaborator of the publisher Éric Hazan at the time, the publication of the book *Valparaíso* took place two months before the exhibition. The book was a critical success and its cover, designed by Barral, was widely imitated (by Anders Petersen, Antoine d'Agata and others). Now out of print, it remains highly sought after by collectors. In Europe it led to a reawakening of the myths surrounding the photographer, who had deliberately vanished from the public eye but was nevertheless rather pleased by this belated recognition. He was certainly delighted by the book and its restrained approach, as several of his letters attest.

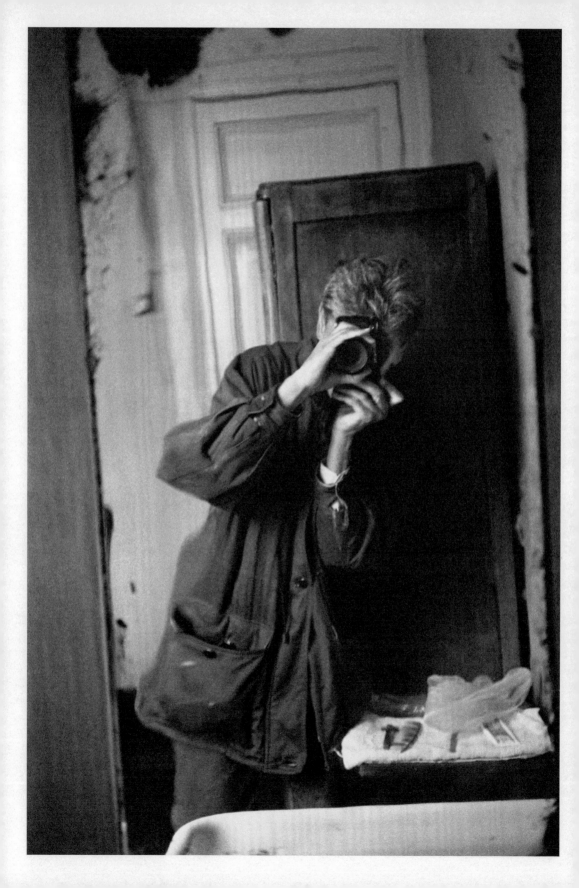

Our correspondence continued. Larrain sometimes posted three letters in one day when he visited Ovalle, the nearest town with a postbox. He often told me that he was working on a new layout for *Valparaíso*, and two years later, in November 1993, I received a new maquette, very detailed and incorporating the previous edition, whose pages he had cut up and inserted. To my great surprise, it had been expanded by adding a great many unpublished images and texts written in a hand that was by now quite familiar to me. This was how I first found out that, in addition to taking a few photographs in the 1980s that I was aware of because I'd seen his contact sheets at Magnum, he had in fact returned to Valparaíso many times since the book's publication. He wanted to integrate these new pictures, compiling a forty-year body of work on the 'Chilean balcony on the Pacific' that was so close to his heart.

This artist's book, in the truest sense, which also included some reproductions of paintings done in Valparaíso, was accompanied by a makeshift package containing all the negatives of the new images, plus some prints. The book itself, the same format as the first but much thicker, was a mixture of pages cut from the first edition (text and photographs), photocopies and prints of other images, a few handwritten lines of poetry and mysticism, and a guide to meditation, aimed at the reader. Perhaps the most unexpected addition was a black-and-white reproduction of a painting by Edward Hopper, *Sunlight in a Cafeteria* (1958), right at the end, stuck in vertically. An echo of the girls sitting in the Siete Espejos in Valparaíso? A sense of empathy with the watchful figure of the man on the right? Larrain did not explain.

Echoing his quest for satori in later life, the more recent images chimed with the handwritten words, forming a kind of mantra that he constantly repeated, such as 'Alham du Lilah' (glory to God) or 'Art is an Approach to the State of Satori'. After experimenting with various metaphysical paths, which led him to a sort of 'fullness of consciousness' that combined different philosophies (Zen, Sufi), Larrain had become a mystic and a loner. In 1978 he had chosen to move far away from everything to live in the mountains of Tulahuén with his young son. From then on, his occasional pilgrimages from this retreat to the 'magic' city only made the photographer-poet more despairing about the dilapidated state of the place, which over the years had become a metaphor for the whole world: 'Valparaíso,' he wrote, 'being one of the most poetic places [on] the planet, is getting destroyed. By abandonment, poverty, and lately by crime.'[13]

This hybrid object, which apparently contains everything that was important to Larrain at that time, may well be the most useful book for anyone who wants to understand the complex personality that is expressed

Self-portrait of Sergio Larrain in Valparaíso, 1992.

within it and the diversity of his talents. What he called his 'yoga', painting, drawing and teaching are combined with photographs of varying degrees of realism, capturing moments of intensity in Valparaíso. This work is a sum total: Larrain did not take any more pictures in Valparaíso over the final twenty years of his life. It could be said that his chosen images are sometimes a little weak when he wants to use them to support an idea, and often most brilliant when they are allowed to stand alone. He worked on the crops and demanded that these be maintained. As for the way we reconstructed his layout for printing, it took us a lot of rifling through contact sheets to find the chosen images; some (a small few) were reproduced only as poor-quality photocopies and could not be found. These have been replaced by a blank page or by another image from among those he selected.

It took a wait of more than twenty years to make this book a reality. Larrain did not wish to publish any more books during his lifetime. The many media attempts to contact him in his Tulahuén retreat had put him off the idea. He asked his children and me to wait until after his death to do so. He was reassured, however, that everything was in good hands at Magnum, the repository where he had decided to leave his archives, on the condition that they abided by his wishes. To be best understood, this book had to wait for the publication of the major Larrain monograph of 2013,[14] which carefully documents the career of 'God's photographer',[15] whose obsession with purity of gesture and transmission of knowledge inspired so many other artists. More than ever before, the terms he used to describe the state of grace he had to enter in order to 'welcome' a great picture were those of mysticism, even spiritualism, as if the images already existed out in the cosmos and the photographer simply acted as a medium. But in this book, the testimonial quality is crucial. It is a call to action, a cry.

A few months before his death in 2012, he agreed to an interview with the Chilean filmmaker Felipe Monsalve, which was not filmed. Larrain immediately asked him not to take photographs. Instead, he gave a lesson in living according to his own tenets and spent some time on the subject of photography: 'Mental discipline teaches you to see and recognize, both in yourself and in others. It's important to learn how to observe, both outside and inside. When you observe your inner world, that's when the mystic dimension appears. It's there that you find spirituality, the potential to grow and expand what we are... Photography is much more than an aesthetic act. It's a form of expression, it's the result of combining your own inner world with light.'[16]

Valparaíso: an enchanted vale, a lost paradise or the reflection of a 'filthy' planet? The labyrinths of steps no longer lead anywhere; the headlong dive into the bars and nightlife, that wellspring of heat and humanity, does not

exist any more; the Siete Espejos has disappeared. But Sergio Larrain, clear-sighted poet, laid down some of the founding myths of this world-like city that beats to the rhythm of Planet Earth. Among the stones and the rubbish dumps grow wild plants that still manage to survive. Sergio Larrain has seen them.

1 Pablo Neruda, *Memoirs* (1974), trans. Hardie St Martin, New York: Farrar, Straus and Giroux, 1977.
2 Sergio Larrain, letter to Henri Cartier-Bresson, 5 June 1962.
3 Sonia Quintana, 'Sergio Larrain, su Majestad el fotógrafo', *En Viaje*, no. 417, July 1968, p. 9.
4 Sergio Larrain, letter to Agnès Sire, 6 July 1987.
5 Claude Nori, 'Sergio Larrain', *Camera International*, no. 29, July 1991, pp. 40–49.
6 Sergio Larrain, *El rectángulo en la mano*, Santiago de Chile: Cadernos Brasileiros, 1963.
7 *Ibid.*
8 Plate 4 of *Valparaíso*, Paris: Éditions Hazan, 1991.
9 Sergio Larrain, letter to Henri Cartier-Bresson, 28 April 1965.
10 The book *Una casa en la arena* (*A House in the Sand*) was published by Lumen in 1966, with photographs by Sergio Larrain and text by Pablo Neruda.
11 Pablo Neruda, *Canto general*, Canto X, section VII.
12 'Valparaíso', Rencontres Internationales de la Photographie d'Arles, Maison Pablo Neruda, 5 July–15 August 1991.
13 See p. 103.
14 *Sergio Larrain: Vagabond Photographer*, ed. Agnès Sire, London: Thames & Hudson, 2013.
15 Marcelo Simonetti, *El fotógrafo de Dios* (*God's Photographer*), Santiago de Chile: Editorial Norma, 2009. This book was heavily inspired by the figure of Sergio Larrain. Julio Cortázar's 1959 short story 'Las babas del Diablo' (The Devil's Spit) was also inspired by Larrain, and was used by Michelangelo Antonioni as the basis for the film *Blow-Up* (1966).
16 Felipe Monsalve, *Homeostasis, Un continuo movimiento de adaptación*, Santiago de Chile: Random House Mondadori, 2013.

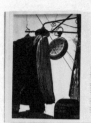

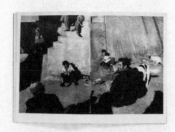
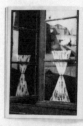
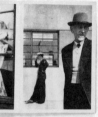
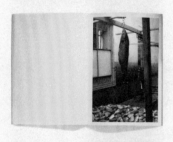
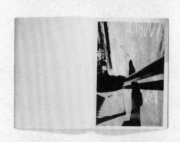
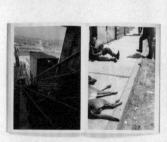
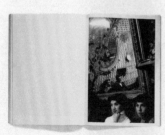
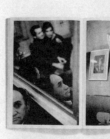
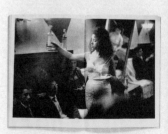
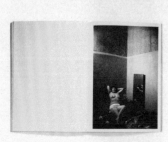
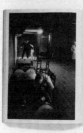
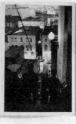
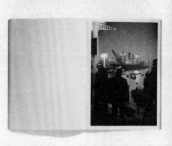

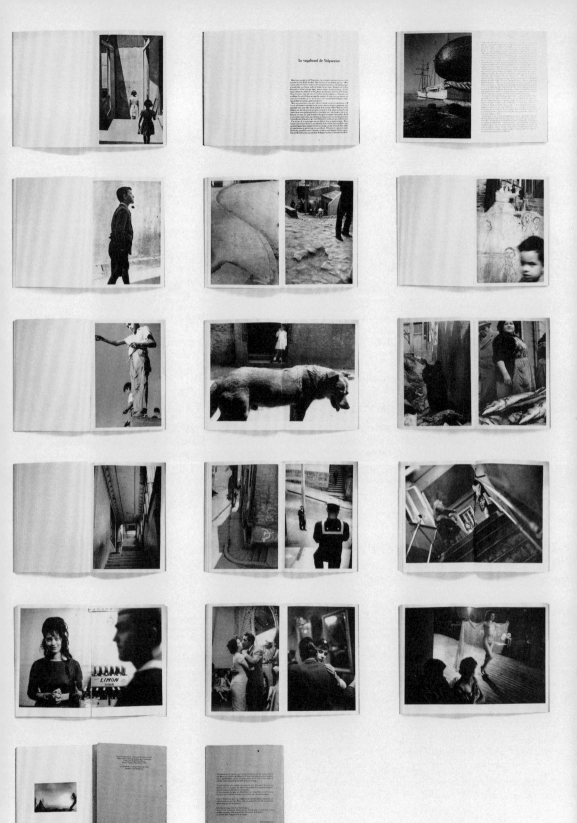

Sergio Larrain, *Valparaíso*, Éditions Hazan, 1991.

Santiago 5-6-62

Dear Henri,

thankyou for your little note. I am always happy to hear
from you.

Here I am, mostly writting.. doing little photography,

I am puzled.. I love ~~(and x inner)~~ photography as a visual arts.. as
a painter loves ~~his~~ painting, and like to practice it in that way..
work that sales (eassy to sale) is an adaptation for me.. ~~is~~ like
doing posters for a painter.. ~~xn~~ ~~I do like doing it~~. ~~at least I feel~~
I feel
~~I loose my time.~~

Good photography is hard to do and takes much time for doing it..
I have been adapting myself ever since I entered your group.. in order
to learn and get publication.. but ~~I would like~~ *WANT* to become serious
again.. there is the problem of markets.. of getting published, of
earning money..
~~xx~~
~~xx~~
~~xx~~

WORKING
I am puzled as I tell you and would like to find a way out for ~~acting~~
in a level, ~~in a way that may be~~ vital for me.. I can't adapt myself
~~much any~~ longer.. so I write.. so I think and meditate.. waiting ~~for ins-~~
~~piration~~ for a clear ~~tendency~~ to grow in me..
direction
~~xx~~
~~xx~~
~~xx~~
~~xxxxxxxx~~

good by, my love for you ~~xxxxxxxxxxx~~

Sergio

Sergio

Letter to Henri Cartier-Bresson, 5 June 1962, Santiago.

Dear Henri,

Thank you for your little note. I am always happy to hear from you.
Here I am, mostly writing, doing [a] little photography...

I am puzzled. I love photography as a visual art, as a painter loves painting,
and like to practise it in that way. Work that sells (easy to sell) is an adapta-
tion for me. It is like doing posters for a painter. (I dislike doing it. At least,
I feel I lose my time.)

Good photography is hard to do and takes much time for doing it. I have
been adapting myself ever since I entered your group, in order to learn and
get publication, but I want to become serious again. There is the problem
of markets... of getting published... of earning money.

I am puzzled as I tell you, and would like to find a way out for working in a
level, in a way; that may be vital for me. I can't adapt myself any longer, so I
write, so I think and meditate, waiting for inspiration, for a clear direction
to grow in me.

I have a nine-month-old girl which I love, a little house which is beautiful,
a kind wife, and a desire for action which I need to concretise. (At a level
that is satisfactory for me.)

Goodbye, my love for you

Sergio

POTOSI- BOLIVIA -V-28-IV-65

MY DEAR HENRY - I WAS VERY HAPPY TO RECIEVE
YOUR LETTER - I HAVE GREAT AFFECTION FOR YOU-
ONE OF THE THINGS THAT MAKES ME SORRY NOT
TO BE IN EUROPE IS NOT SEING YOU- BUT IT IS
BETTER - FOR THE TIME BEING AT LEAST - (AND HAS
BEEN) - MY STAYING ARROUND HERE - WHERE LIFE
IS SLOWER - ~~MORE~~ SIMPLER-RURAL ALMOST - AND I HAVE
BEEN CENTERING MYSELF - COMING BACK TO EARTH -
BECOMING MATURE - (WITH HAPPINESS) (IN PARIS /EU-
ROPE - I WAS LIVING ALONE IN MY ROOM - IN HOTELS
AND RESTAURANTS . AND IT WAS TOO HARD) -
 MY WORK ? I UNDERTOOK THE
GREAT 'ENTREPRISE' OF DOING A STORY ON A SUB-
JECT I HAD GREAT FILING FOR - DEVOTING TO IT
ALL MY CAPACITY - NOT CONSIDERING TIME (OR MO-
NEY) ~~AND~~ I WORKED TWO YEARS ON VAL-
PARAISO — A MISERABLE AND BEAUTFULL PORT -
I CAME OUT WITH A VERY STRONG CODECTION
OF PHOTOGRAPHS. A ~~LITT~~ BIT SORDID AND
ROMANTIC - ~~I MOUNTED THEM ON A~~
DID A DUMMY DÜ SIZE WITH THEM - AND IT
WENT ARROUND NEW YORK SHOWING ~~THE~~
~~WORK~~ - (NERUDA HAD WRITEN SOME
TEXT ON THE SUBJECT - EVEN THOUGH
NOT MUCH RELATED) PEOPLE WERE IMPRE-
SSED BY ~~THIS~~ - BUT NO ONE WANTED TO
PUBLISH IT (PROSTITUTES- DANCING PLACES-
ETC.) - NOW IT IS AT DÜ - FOR
~~W~~ WHOM I ORIGINALY PLANNED IT - AND
IT IS GOING TO COME OUT - WHEN?

I DON'T KNOW -
 THEY ARE HAVING AN EXHI-
BITION OF 100 OF MY PHOTOGRAPHS (MY WHOLE
WORK - I WOULD SAY) - AT THE CHICA-
GO ART INSTITUTE - NEXT AUGUST /SEPTEM-
BER- GO AND SEE IT IF YOU ARE NEAR -

Letter to Henri Cartier-Bresson, 28 April 1965, Potosí, Bolivia.

My dear Henri,

I was very happy to receive your letter. I have great affection for you. One of the things that makes me sorry not to be in Europe is not seeing you. But it is better, for the time being at least (and has been) my staying around here, where life is slower, simpler, rural almost, and I have been centering myself, coming back to Earth, becoming mature (with happiness). (In Paris/Europe, I was living alone in my room, in hotels and restaurants, and it was too hard.)

My work? I undertook the great 'enterprise' of doing a story on a subject I had great feeling for, devoting to it all my capacity, not considering time (or money). I worked [for] two years on Valparaíso – a miserable and beautiful port. I came out with a very strong collection of photographs. A bit sordid and romantic. I did a dummy (*Du* size) with them and went around New York showing it (Neruda had written some text on the subject, even though not much related). People were impressed by this but no one wanted to publish it (prostitutes, dancing places, etc.). Now it is at *Du*, for whom I originally planned it, and it is going to come out. When? I don't know.

They are having an exhibition of 100 of my photographs (my whole work, I would say) at the Chicago Art Institute next August/September – go and see it if you are near.

AND NOW I AM AT POTOSI- BOLIVIA-
PHOTOGRAPHING THIS VERY INTERESTING CITY-
I DO THIS FOR HOLIDAY — EVEN THOUGH
I DON'T KNOW IF ~~I AM G~~ IT IS GOING
TO BE ACCEPTED- IT WAS ME WHO PRO-
POSED THE SUBJECT — AND OFFERED THEM
TO DO IT FOR A SMALL GUARANTY —
FOR IT IS A STORY I REALY WANTED TO
DO — AND I TRY TO DO
ONLY WORK THAT I REALY CARE
DOING — FOR IT IS THE ONLY
WAY OF KEEPING ME ALIVE PHOTOGRA-
PHICALY — AND I TAKE AS MUCH TI-
ME AS I FEEL TAKING — ~~AND WANTS~~
~~TO HAVE~~ AND KEEP MY SELF IN A
SLOW PACE? — WITH MUCH TIME FOR
MYSELF AND DOING OTHER THINGS —
AND SEE HOW PHOTOGRAPHY DEVELOPS-
..IF IT CONTINUE TO DEVELOP — AND
UNCERTAIN OF MY SURVIVAL (IN
THE MARKETS) — BUT HAPPY — FOR
I DO WHAT I WANT THE WAY
I WANT —

 I FEEL THAT THE
RUSHING OF JOURNALISM — BEING REA-
DY TO JUMP ON ANY STORY — ALL THE
TIME — DESTROYS MY LOVE AND CONCENTRA-
TION ~~FOR~~ WORK — GOOD BY HENRY —
WISH I COULD SEE YOU — ~~WITH~~ MY LOVE — sérgio

[continued]
And now I am in Potosí, Bolivia, photographing this very interesting city. I do this for *Holiday* [a magazine], even though I don't know if it is going to be accepted. It was me who proposed the subject and offered them to do it for a small guarantee, for it is a story I really wanted to do.

And I try to do only work that I care [about] doing, for it is the only way of keeping me alive photographically, and I take as much time as I feel [like] taking, and keep myself in a slow pace with much time for myself and doing other things and see how photography develops – if it continues to develop and uncertain of my survival (in the markets) – but happy, for I do what I want.

I feel that the rushing of journalism – being ready to jump on any story all the time – destroys my love and concentration for work.

Goodbye Henri, I wish I could see you.

My love,
Sergio

6 july 91 — AGNES

Yesturday was the oppening of our exhibition, and the book must be on,
how exiting. It was the 18th. birthday of Juan José. (Only a few years
ago I used to watch his botom in the lavatory, with one hand, and while
holding him with another).

What I like about metier, and quality, is that it brings hapines, and desi de
re to do good things to others, the contrary when one does comercial
work, or for prestige.
It is mental health, among the cultivators of the metier, and social heal
th, when things are done with care and love. Esential. For that, one needs
to live frugaly. You saw Josef building his carreer from living in slee-
ping bags, no expenses. Is the way to have freedom of spirit, and in
that way be happy and enjoy looking, and painting, or photography. A monks-
cell, an atelier, minimum expenses, and you can develop your craft with
care, like a gardener, no pushing, no forcing, just care and peace. Qua-
lity.

You are learning the craft too, of putting toguether the work of photo-
graphers, and publishing them, editor, is wanderfull, in France they ha-
ve an art in that, see the Verve# collection, that is the top.

Henri can tell you about that. His two big boks, the one with matisse
cover, the other with miro's are part of that spirit. The top ever done
in the planet. See that. Quality.

A culture is born out of hapiness, people prefer life than fighting, and
they can be brought to accept order, and limitations, slowly.
We have to solve the whole planet, that is our task, all of us..
the voyage in the 4th. dimention, time, is called: evolution or degra-
dation.
It is played in the present, always, by responding 100% to every situationtic
reality presents's us with, with love and inteligence.

Slowly. Love

 S.

also Minotaure. The magazine.

Letter to Agnès Sire, 6 July 1991.

Agnès,

Yesterday was the opening of our exhibition and the book must be [out], how exciting. It was also the 18th birthday of Juan José. (Only a few years ago I used to wash his bottom in the lavatory with one hand, while holding him with another.)

What I like about metier, and quality, is that it brings happiness and desires to do good things to others, the contrary when one does commercial work or for prestige.

It is mental health, among the cultivators of the metier, and social health, when things are doing with care and love. Essential. For that, one needs to live frugally. You saw Josef [Koudelka] building his career from living in sleeping bags, no expenses. It is the way to have freedom of spirit, and in that way be happy and enjoy looking, and painting, or photography. A monk's cell, an atelier, minimal expenses, and you can develop your craft with care, like a gardener, no pushing, no forcing, just care and peace. Quality.

You are learning the craft too, of putting together the work of photographers, and publishing them. Editing is wonderful. In France they have an art in that, see the Verve* collection, that is the top.

Henri [Cartier-Bresson] can tell you about that. His two big books, the one with [a] Matisse cover, the other with Miró's, are part of that spirit. The top ever done on the planet. See that. Quality.

A culture is born out of happiness, people prefer life [to] fighting, and they can be brought to accept order, and limitations, slowly. We have to solve the whole planet, that is our task, all of us, the voyage in the 4th dimension, time, is called evolution or degradation. It is played in the present, always, by responding 100% to every situation reality presents us with, with love and intelligence.

Slowly. Love
S.

* also *Minotaure*, the magazine.

8 JULY OVACLE ♡

A BEAUTY THE BOOK!
A REAL JEWEL -
THE COVER OF RECICLED
PAPER THE BEST THAT
COULD BE FOUND - LIKE MOTHER
EARTH - MATIERE - (MATER).
 MOTHER.
- A BIG BIG HUG FOR SO

MUCH LOVE AND WORK.

I WICH I COULD GO TO

PARIS SO WE COULD

CLIMB TO BUDA LEVEL -

MAY BE IT WILL COME

 ALL MY LOVE! ♡
 SERGO.

MAGNIFICENT! CHOICE OF
PICTURES. AD. AND LAY OUT.

Letter to Agnès Sire, 8 July [1991], Ovalle.

A beauty, this book! A real jewel.

The cover of recycled paper – the best that could be found. Like Mother Earth – Matière (Mater). Mother.

A big big hug for so much love and work.

I wish I could go to Paris so we could climb to Buddha level.
Maybe it will come.

All my love!

Sergio

Magnificent! Choice of pictures and layout.

REALY TOP LITTLE BOOK — BORN
OF LOVE — THE TRANSLATION IS
VERY GOOD — GIVE CONGRATULATIONS
TO THE TRANSLATOR.

DO SEND A COPPY TO
~ OSCAR ICHAZO

[redacted]
[redacted]
[redacted]

AND GIVE ONE TO HENRI —
ANOTHER TO JOSEF — ONE
TO RENE — ONE TO MARC
ONE TO JOHN MORRIS

[redacted]
[redacted]
[redacted]

ONE TO THE LE MONDE REPORTER
IN SANTIAGO — THROUGH THE
NEWSPAPER — ON MY ACCOUNT —
BESOS! — AD· ♡

· ONE TO DENIS SNOCK.
·· ONE TO BRUCE —
· ONE TO ELICH HARTMAN
ONE TO BERNARD PLOSSU

[continued]
Really top little book, born of love. The translation is very good
- give congratulations to the translator.

Do send a copy to:
Oscar Ichazo

▆▆▆▆▆▆▆

▆▆▆▆▆▆▆

▆▆▆▆▆▆

• One to Den[n]is Stock
• One to Bruce [Davidson]
• One to Erich Hartman[n]
• One to Bernard Plossu

▆▆▆▆▆▆▆▆▆▆▆▆

▆▆▆▆▆▆▆

And give one to Henri [Cartier-Bresson], another to Josef [Koudelka],
one to René [Burri], one to Marc [Riboud]

One to John Morris

▆▆▆▆▆▆▆▆▆

▆▆▆▆▆

One to the *Le Monde* reporter in Santiago, through the newspaper,
on my account.

Kisses!
AD

15 july
Agnes, the prints done by the lab. for the book are
exelent. So is the impresion. All is good craftmanship,
in it's level. Healthy.
Do give books to the different persons that worked in
producing it. Charge them to me. for people
to see what they have achieved, and have it, be part of
it. A common achievment.ad
 Love
 S.
PS. Later- I am delighted with the book, I look at it again
and again- Ilike the format, the cover, the printing, the
enlarging, the lay out, the text. Realy a gem. Light, happy,

good craft, poetry, one seldom sees in books.

Letter to Agnès Sire, 15 July [1991].

Agnès,

The prints done by the lab for the book are excellent. So is the impression.
All is good craftsmanship in its level. Healthy.

Do give books to the different persons that worked in producing it. Charge
them to me. For people to see what they have achieved and have it, be part
of it. A common achievement.

Love
S.

PS. Later – I am delighted with the book, I look at it again and again. I
like the format, the cover, the printing, the enlarging, the layout, the text.
Really a gem. Light, happy, good craft, poetry one seldom sees in books.

September, 1993. Ovalle.

Agnes,

here goes the finished Valparaiso portfolio.
40 years! of photography, of different epochs, from 1952
to 1992.

I did eliminate the weak photos from our previous book.

If the book is re-published, you propably can simplify it,
eliminate what is weak, another order.. a new form. IF ONE REACHES
THE SAME EFFECT WITH LESS ELEMENTS, IT IS BETER ART.. Albers.

But I send you all I have , one can keep
only the best photos, and do a better book, is your possibility.
But I wanted to give all I have, wich is worth while.

Besides the photographic portfolio, there is an explena-
tion, and understanding, of what satori is. Wich is important.
And the present situation of the city, and it's possible fate.
And by extention, the situation of the planet, and it's possible
solution.

So I am giving all I have

Show this to Martine, Josef and Henri, they will enjoy it.

I am including 26 new rolls with their contacts. Of photos
taken in the last 3 years. Do have them well contacted and filed.
Make one big story out of the different takes on the city.

The photograph in page 68, is a 6x6 negative, that could
be on the files, among other 6x6 negs on Valparaiso. Do look for
it. There are several 6x6 takes on the city.

My next portfolio, will be Viña del Mar, that I am enlarging
and will send when ready.

Afterwards I want to do posters, with objective fraces.

So. This is my 100% on the city.. and on everything else.

Do receive my love,

Sergio. ad.

PS. Do send me a note when you receive this, so I know it
has reached you. ad.

PPS. The book is a little bit complicated, because it has se-
veral elements in it:

1. a portfolio, that you can sellect, organise
 and produce a better, more complete Valparaiso
 book with.
2. Neruda's text, wich is exellent.
3. Satori, the fraces related to it, and the
 explenation of what it is.
4. The city's fate, and possible solution.
5. The planet's fate, and it's possible solution,
 (by extention).

All this components are important, and can be, or not,
used toguether, you have to see. I send all I have. Besos. AD.

Letter to Agnès Sire, September 1993, Ovalle.

Agnès,

Here goes the finished Valparaíso portfolio. 40 years (!) of photography, of different epochs, from 1952 to 1992. I did eliminate the weak photos from our previous book. If the book is re-published, you probably can simplify it, eliminate what is weak, another order, a new form. IF ONE REACHES THE SAME EFFECT WITH LESS ELEMENTS, IT IS BETTER ART – [Josef] Albers. But I send you all I have. One can keep only the best photos, and do a better book, [it] is your possibility. But I wanted to give all I have, which is worthwhile. Besides the photographic portfolio, there is an explanation and understanding of what satori is. Which is important. And the present situation of the city and its possible fate. And by extension, the situation of the planet and its possible solution. So I am giving all I have.

Show this to Martine, Josef and Henri, they will enjoy it.

I am including 26 new rolls with their contacts, of photos taken in the last two years. Do have them well contacted and filed. Make one big story out of the different takes on the city. The photograph [on] page 68 is a 6 × 6 negative that could be on the files, among other 6 × 6 negs on Valparaíso. Do look for it. There are several 6 × 6 takes on the city. My next portfolio will be Viña del Mar, that I am enlarging and will send when ready. Afterwards, I want to do posters, with objective phrases.

So. This is my 100% on the city... and on everything else.
Do receive my love,

Sergio. AD.

PS. Do send me a note when you receive this, so I know it has reached you. AD.
PPS. The book is a little bit complicated because it has several elements in it:
 1. A portfolio that you can select, organise and produce a better, more complete Valparaíso book with.
 2. Neruda's text, which is excellent.
 3. Satori, the phrases related to it, and the explanation of what it is.
 4. The city's fate, and possible solution.
 5. The planet's fate, and its possible solution (by extension).
All these components are important, and can be, or not, used together. You have to see. I send all I have. Kisses. AD.

The publishers and Agnès Sire
would like to thank:

Gregoria Larrain
Juan José Larrain

Éric Hazan
René Solis
Enrico Mochi
Magnum Photos
Éditions Gallimard
The Pablo Neruda Foundation
The Carmen Balcells Literary Agency
Éditions Hazan

The page numbers in this book are replicated from Sergio
Larrain's original handmade layout. To respect his vision,
inconsistencies in the numbering have been retained.

First published in the United Kingdom in 2017 by
Thames & Hudson Ltd, 181A High Holborn, London WC1V 7QX

First published in the United States of America in 2025 by
Thames & Hudson Inc., 500 Fifth Avenue, New York, New York 10110

Published by arrangement with Atelier EXB, Paris
Translated from the French *Sergio Larrain, Valparaíso*
Original edition © 2016 Atelier EXB, Paris.
This edition © 2017 Thames & Hudson Ltd, London
Photographs © Sergio Larrain/Magnum Photos.
Text © 2016 Agnès Sire, translated from the French.
Text by Pablo Neruda © 1977 Farrar, Straus and Giroux, Inc.
Painting by Edward Hopper, *Sunlight in a Cafeteria*, 1958: Yale University
Art Gallery, Bequest of Stephen Carlton Clark, B.A. 1903.

British Library Cataloguing-in-Publication Data
A catalogue record for this book is available from the British Library

Library of Congress Catalog Card Number 2024935915

ISBN 978-0-500-54480-8

Printed in Germany

here goes the finished Valparaiso portfolio.
40 years! of photography, of different epochs, from 1952
to 1992.